THE COVERED BRIDGES
OF MONROE COUNTY

THE
COVERED BRIDGES
⬦—• OF •—⬦
MONROE COUNTY

JEREMY BOSHEARS

AN IMPRINT OF
INDIANA UNIVERSITY PRESS

This book is a publication of

QUARRY BOOKS

An imprint of
INDIANA UNIVERSITY PRESS
Office of Scholarly Publishing
Herman B Wells Library 350
1320 East 10th Street
Bloomington, Indiana 47405 USA

iupress.indiana.edu

Cataloging information is available from the Library of Congress.

ISBN 978-0-253-04128-9 (paperback)
ISBN 978-0-253-04130-2 (ebook)

1 2 3 4 5 24 23 22 21 20 19

Everyone who remembered these bridges had stories to tell about the ones they frequently traveled across or were close to where they lived. There is one person though who had the most stories to tell and remembered ten of the thirteen bridges. Local resident Dale McClung of Unionville told stories of these bridges from when he was a child (born 1925) up through the days when he drove a DX fuel delivery truck. Dale began delivering fuel in the 1940s and drove all over Monroe and surrounding counties. He said of all the bridges he crossed, "The Judah Bridge was the one you didn't want to cross with a full load of fuel." He told me that he wished he taken more photos of the covered bridges. "You wouldn't think of taking a picture of a concrete bridge out on Highway 37, but one day it will be gone or changed. The covered bridges disappeared one by one until they were all gone."

Edwin Dale McClung
1925–2012

CONTENTS

Acknowledgments *ix*

1 Early Travelers *3*

2 The Builders *9*

3 Church Bridge *13*

4 Cutright Bridge *24*

5 Dolan Bridge *30*

6 Fairfax Bridge *37*

7 Goodman Bridge *45*

8 Gosport Bridge *53*

9 Harrodsburg Bridge *70*

10 Johnson Bridge *79*

11 Judah Bridge *88*

12 McMillan Bridge *95*

13 Mount Tabor Bridge *108*

14 Muddy Fork Bridge *113*

15 Nancy Jane Bridge *116*

16 GPS Locations and Directions *125*

Index *133*

ACKNOWLEDGMENTS

THANKS TO EVERYONE WHO HELPED ME WITH PHOTOS and information. These names are in no particular order: John Frye, Gerald Boshears, Jim Barker, Todd R. Clark, Ron Branson, Trish Kane, Joseph Conwill, Terry Miller, Bill Caswell, Mary Pat Kroger, Tristan Johnson, Brad Cook, Bill Oliver, Phil Childress, Pete Pedigo, Ron Marquardt, Andy Rebman, Martha Belle Young, Diane Young, Robert (Bob) Naylor, Bettye Lou Collier, Mark Stanger, Larry Stanger, Dale McClung, Martha Fox, Bob Wiliamson, Don Chitwood, Naomi Norman, Harold Martin, Steve Martin, Betty Kerr, Everett Kerr, Daniel Scherschel, Joe Peden, Lisa Ridge, Ashley Cranor, Laura Lane, Dalane Anderson, Rick Hackler, Susie Dumond, Judi Roberts, Justin Maxwell, Rex Watters, Dan Wagoner, the Smithville Area Association, the Monroe County Historical Society, the Indiana Covered Bridge Society, the Covered Spans of Yesteryear, the National Society for the Preservation of Covered Bridges, the Gosport Museum, the Monon Historical Society, and the Indiana Historical Society.

This project started in 2009 when my friend John Frye showed me a picture he found while searching through a photo collection. It was listed as "Bridge three miles South of Unionville." At first I thought it had to be a mistake, and I couldn't figure out where that could be. Little did I know that a single picture of the Church Bridge would spark an interest in me to start collecting more pictures and information. I have searched through the Monroe County Commissioners' records from 1818 to 1900, traveled all over Monroe County taking pictures, made trips to Indianapolis, and spent countless enjoyable hours visiting with people going through photo collections and hearing their stories all in an effort to compile the best collection of pictures and the most information possible. I have pictures from local families and from some people as far away as Maine.

All of the technical information in this book is from the Monroe County Commissioners' records, and after doing my research, I found that Terry Miller did similar technical research in 1968–1969. All of my information is the same as Terry's, which leads me to believe that it is correct.

THE COVERED BRIDGES
OF MONROE COUNTY

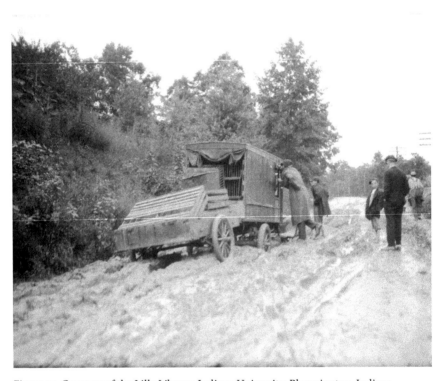

Figure 1.1. Courtesy of the Lilly Library, Indiana University, Bloomington, Indiana.

1

EARLY TRAVELERS

Early residents in Monroe County faced many obstacles during their travels. Roads were rutted and muddy several months of the year, making them nearly impassable (see fig. 1.1). Only during the dry summer months did road conditions improve.

Some creeks were used for roads because there weren't very many crushed stone or macadamized roads in remote areas, and the gravel from creeks was used in some locations. Figure 1.2 shows a road in the creek from the 1920s.

Crossings known as *fords* were a way of traversing creeks before bridges were built and during the rainy seasons would become flooded and impassable. Figure 1.3 shows a man with a team of horses and a wagon approaching a ford.

Creeks that were too large to ford would sometimes have ferries to transport people, animals, automobiles, and goods. In 1818, when Monroe County was formed, there were several ferries in service. They were at locations on the White River, Clear Creek, Salt Creek, and Bean Blossom Creek. Several of these locations would later have piling bridges and eventually covered bridges. Figure 1.4 shows an automobile being transported on a ferry.

Piling bridges were built in some locations around the county. These bridges had an average life-span of five to ten years. They weren't protected from the elements and would become rotten, sometimes collapsing with a heavy load. The pilings were driven into the creek bottom but could get damaged during a flood or completely washed out when debris would pile up against them. In figure 1.5, the crawler in the creek is removing debris that has built up against the pilings of this bridge in 1930.

In Monroe County there are three major creeks: Bean Blossom Creek in the north, Salt Creek in the southeast, and Clear Creek in the south central. Some parts of these creeks were large enough to navigate with flatboats, but they also

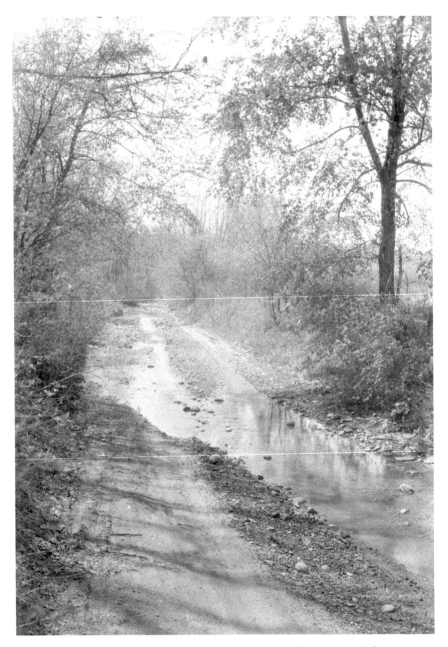

Figure 1.2. Courtesy of the Lilly Library, Indiana University, Bloomington, Indiana.

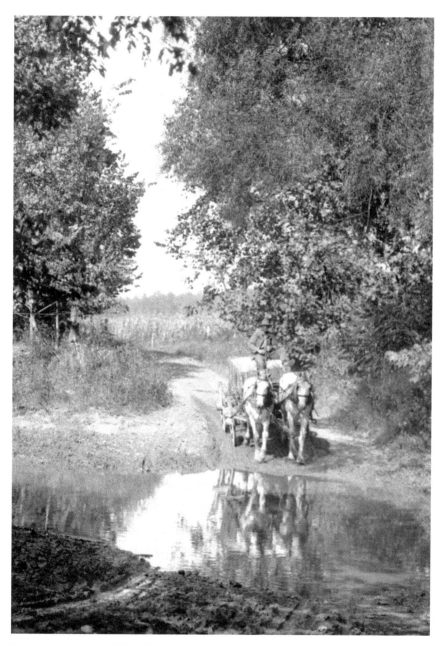

Figure 1.3. Courtesy of the Lilly Library, Indiana University, Bloomington, Indiana.

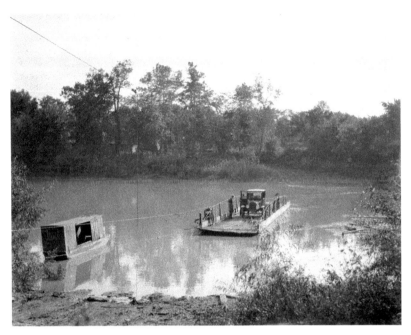

Figure 1.4. Courtesy of the Lilly Library, Indiana University, Bloomington, Indiana.

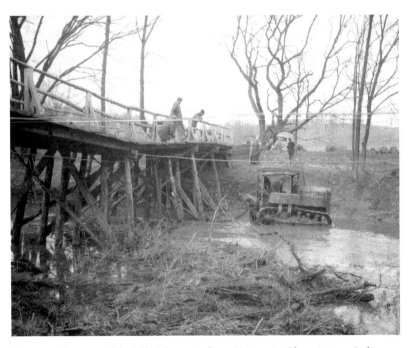

Figure 1.5. Courtesy of the Lilly Library, Indiana University, Bloomington, Indiana.

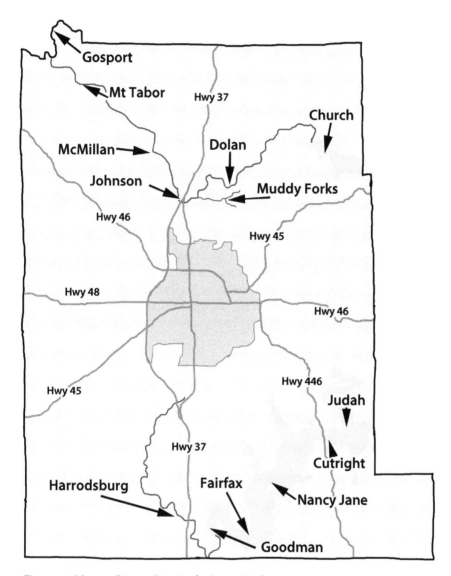

Figure 1.6. Monroe County. Drawing by Jeremy Boshears.

posed a problem for travelers who had to cross them. Fords were used in some locations, ferries in others. Piling bridges were eventually built but only lasted five to ten years, and a better type of bridge was needed. Covered bridges solved the problems that plagued the piling-style bridges. They had roofs and siding to protect the superstructure from the elements, and the single span of this style of bridge was self-supporting and didn't use pilings, making them less prone to washout. Stone abutments were built for the bridges, which didn't rot like wooden ones and also kept the bridge above the water during floods.

None of the thirteen covered bridges that were in Monroe County are left today. Bean Blossom Creek had five covered bridges with one low truss bridge over the Muddy Fork. Salt Creek had five, Clear Creek had one, and the White River had one triple-span bridge at Gosport, connecting Owen and Monroe Counties (see fig. 1.6).

The last covered bridge in Monroe County was lost to arson on June 29, 1976, about six years after it had been restored. This book will take you on a trip back in time with photos of the bridges and tell the stories of local residents who remember them. Whether you remember these bridges or have never seen them before, enjoy your journey as you travel back in time to the covered bridges of Monroe County.

2

THE BUILDERS

IN MONROE COUNTY FOUR STYLES OF TRUSSES WERE used in building the covered bridges, and four builders were responsible for the erection of them. The Smith Bridge Company of Toledo, Ohio, was responsible for the majority of the building. At the time these bridges were built, other companies submitted bids for iron bridges. But the cost of the covered bridges was lower, and the Smith Bridge Company was chosen for the contract. Monroe County Commissioners' records do show that the company also built some small iron bridges in the county.

In 1833 Robert Smith was born in Miami County, Ohio. His father was a cabinetmaker, and Robert worked as a carpenter when he was a young man. In 1867, at age thirty-four, he received his first bridge patent and built five bridges that year. In 1868 he built twenty-two bridges. In 1869 he built seventy-five, and that same year he moved his operation to Toledo, Ohio, where he remained as president of the company until 1890. The diagram in figure 2.1 shows the style of a Smith truss used in Monroe County.

The design of this bridge only used iron hardware for the fasteners to bolt the timbers of the bridge together, though some of the bridges had vertical iron tension rods installed later for added strength. A unique feature of this design is

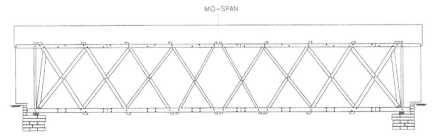

Figure 2.1. Smith truss. Drawing by Jim Barker.

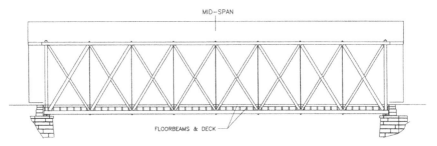

Figure 2.2. Howe truss. Drawing by Jim Barker.

the slightly angled timbers at the end of the truss that are notched into the diagonals and rest on an iron casting. Also note that at midspan, all the diagonals extend through the upper and lower chords of the bridge. Smith began using this design in 1870 and did so when building the first bridge in Monroe County. This design was used on the Church, Gosport, Harrodsburg, and McMillan Bridges. The Muddy Fork Bridge used a Smith low truss design.

Another common style of truss used in Monroe County was the Howe truss. It was designed by William Howe of Spencer, Massachusetts, and patented in 1840. This bridge used vertical iron rods and large arrow-shaped castings that the diagonal timbers rested upon at the top and bottom chords of the bridge. The Smith Bridge Company, the Western Bridge Company, and Thomas A. Hardman used this design for five bridges in Monroe County.

The Western Bridge Company was located in Fort Wayne, Indiana. This company was formed by the Wheelock Bridge Company and C. S. Olds in 1877 to build iron bridges. The Wheelock Bridge Company was started by Alpheus Wheelock, and six bridges were built from 1870 to 1872. Alpheus had worked with other people to build some structures and bridges in previous years. The Western Bridge Company built the covered bridge in Dolan.

Thomas Hardman of Brookville, Indiana, built nine covered bridges in Indiana and also took on other projects. His name appears in the May 23, 1916, issue of the *Bloomington Evening World* for laying twelve thousand feet of twelve-inch pipe from Leonard Springs to the city (Bloomington) waterworks. Thomas Hardman built the Goodman and Johnson Bridges.

The Smith Bridge Company also built the Cutright and Fairfax Bridges using Howe trusses.

The majority of a Howe truss bridge, shown in figure 2.2, is made with wooden timbers; the small vertical lines in the drawing are the iron tension rods. Large arrow-shaped iron castings were mounted into the upper and lower chords of the bridge for the diagonal timbers to rest upon.

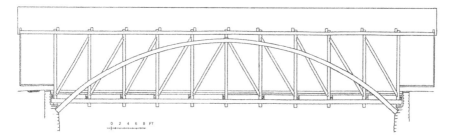

Figure 2.3. Burr arch truss. Drawing by Jim Barker.

Three generations of the Kennedy family built bridges in which they used the Burr arch design. The Burr arch was invented by Theodore Burr in 1804 and patented in 1817. This design combined a king-post truss (which dates back to Roman times) with an arched timber that Burr added for increased strength. The king-post truss alone would support the bridge, but the added arch helps carry the load, making for a very strong bridge design.

Archibald McMichael Kennedy was born in North Carolina in 1818, and his family moved to Indiana when he was young. At age twenty-three he began working as a carpenter and in 1853 moved to Wabash County, where he built some small bridges that same year. He built his first covered bridge in 1870 over the Whitewater River near Dunlapsville. His son Emmett began helping build bridges in 1871, as did another son, Charles, in 1883. Emmett and Charles took over the company in 1883, when Archibald was elected to be an Indiana senator. In 1882 Emmett built a forty-two-inch-long wooden model of their bridge design that was used to show commissioners when bidding on contracts. He would place the model on two chairs and stand on it to show that it would support his weight of 250 pounds. Emmett retired from bridge building in 1892 but came back to build bridges with his son Karl in 1914. His other son, Charles R., joined the group in 1916, and the company completed its last bridge in 1918.

The drawing in figure 2.3 shows the typical truss design that the Kennedy family used on the Judah and Nancy Jane Bridges.

As seen in this drawing, the large arch of the bridge rests on the stone abutments and helps carry the load of the bridges. The king-post portion of these bridges are the timbers, which are vertical and angled. Note that all angled timbers point toward the center of the bridge.

Though all of these truss styles were different, they depended on the timbers staying dry. The roofing and siding protected the structure of the bridge, but when they were not properly maintained, the bridge would eventually become weak. The upper and lower chords of the bridges were laminated, and the timbers

that intersected these could become rotten if they were continually wet from the rain. Many people think that the roof and siding of a covered bridge were built to look like a barn so that horses would pass through more willingly. Though this design may have helped the horses, the sole purpose was to protect the structure of the bridge from the elements. When measuring a covered bridge, the length is determined by the structure that sits on the abutments. The part of the bridge referred to as the overhang does not carry any load. It is added length that protects the timbers sitting on the abutments from the elements.

3

CHURCH BRIDGE

1874–1952

The Church Bridge, also listed as the Fleener Bridge on the 1895 map, was located next to the original location of the Bridge Church of Christ, which was established in 1881. Listed as number 14-53-08, this bridge crossed Bean Blossom Creek in Section 34, Township 10 North, Range 1 East, Monroe County. The single-span bridge was 102 feet long with a 4-foot overhang at each end. It had a five-ton load limit, and the specifications from the 1874 commissioners' records are as follows: "Smith Truss, 16' wide, 15'-3" high, floor joists 2½" thick, 12" wide, and 20' long of oak; plank is 2½" thick, 6" wide, laid diagonally and of oak; all timbers of white pine. Siding is 1" x 12" planed on one side and covered with moulded batten, roof of pine shingles, laid 5 ½" to the weather. Painted with 2 coats of mineral paint with oil."

The Smith Bridge Company received $1,938.00 for building the bridge at a cost of $19.00 per foot. James Russell and Company built the cut-stone abutments for $2,773.90 at a cost of $4.25 per cubic yard. A sheet metal roof replaced the wooden shingles around the 1920s. The bridge was built in 1874 and used for seventy-eight years until it was removed in 1952 as part of the Lake Lemon reservoir project. During the construction of Lake Lemon, the roofing and siding were removed, but the bridge was still used by workers building the dam.

John Johnston operated a ferry across Bean Blossom Creek at this location before there was a bridge. He lived in a house at what was later known as the John Riddle Farm and today is known as Riddle Point. A piling bridge was built at this location before the covered bridge. Monroe County Commissioners' records from December 1873 show an inspection report for the condition of a bridge at this location that was in need of repairs.

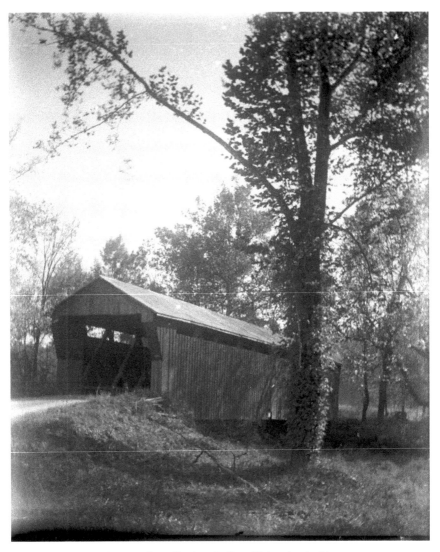

Figure 3.1. Benjamin W. Douglas collection, Indiana University Archives.

Local resident Dale McClung remembers that during the 1930s, a steam trac-
tion engine was being moved to the north side of the creek. While crossing the
bridge, cinders from the smokestack caught the roof on fire, but the flames were
put out before the bridge was severely damaged.

The bridge connected Unionville residents with the Martinsville Pike, which
crossed the Gosport–Columbus road a few miles to the north. No other bridges

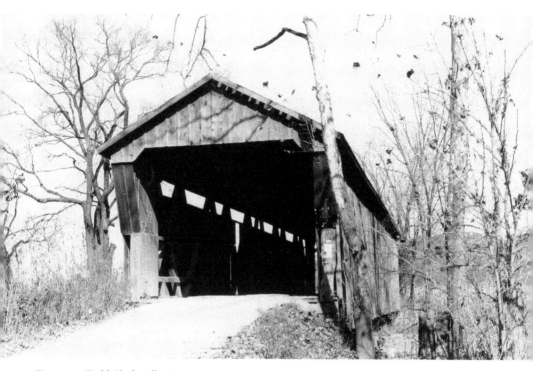

Figure 3.2. Todd Clark collection.

were located in this area in 1874. Polley Ford was located to the west and Hides
Mill Ford to the east. A steel suspension bridge was built during the mid-1880s
at Hides Mill Ford after it became impassable. The Bridge Church of Christ was
located southwest of the bridge, and a small graveyard was located less than an
eighth of a mile west of the bridge beside the creek on a small hill, which today is
known as Cemetery Island.

The photo in figure 3.1, taken in 1936, shows the northwestern corner of the
Church Bridge. The north end of the bridge can be identified by the square-cut
top corners of the portal; the south portal had angled corners. This is the only
known photo of the north side.

The road in figure 3.2 is known as Tunnel Road today. The boat ramp at
Riddle Point Park is actually the old road that led to this bridge. A few boards are
missing from the west side of the bridge about halfway across, and light can be
seen shining through in this view of the south portal from the 1940s.

The date that this photo of the south portal (fig. 3.3) was taken is unknown.
Election posters with the names Baxter, Welch for auditor, and Treasurer Will C.
Reeves can be seen on the left side.

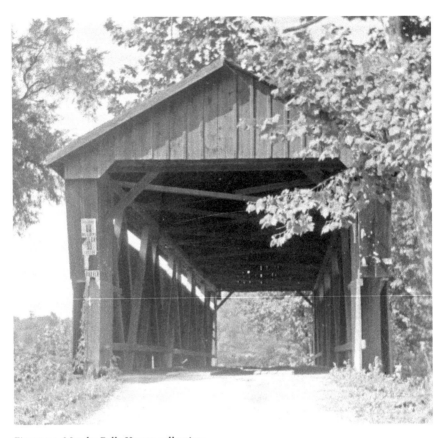

Figure 3.3. Martha Belle Young collection.

A panoramic view from 1951 (fig. 3.4) shows the west side of the bridge as viewed from the cemetery. The rear of the church can be seen to the right, and John Young Road intersects Tunnel Road at the bridge. The creek banks are being cleared for the lake, and some trees in the distance are cut and laying on the ground.

Everett Kerr remembers the Bean Blossom bottom being cleared. "Everything was cleared by hand with chainsaws. The trees were piled and burned. The bottom had to be plowed and Carl Riddle had the contract. I plowed with my 1949 Ford tractor that I bought in 1950. We plowed August, September, and October and spent as much time cleaning the weeds off the plow as we did plowing. The weeds were bad since they had been left to grow all year. 1952, that's the same year I married Betty."

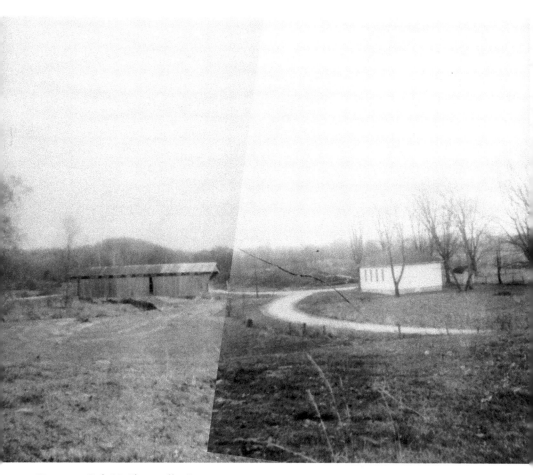

Figure 3.4. Dale McClung collection.

Local resident Dale McClung remembers that young boys enjoyed swimming in a deep area below the bridge.

> Back then most of the boys didn't have swimsuits so they swam in the nude. Generally there wasn't much traffic, only a couple of cars a day on the bridge. So John Fleener decided he was going to be brave. He climbed the creek bank and was going to run across the bridge and jump back in the water on the other side. When he was halfway across the bridge a car entered one end. Luckily for him there were a couple of boards missing on the West side of the bridge. He was quite brave after all because he climbed through the opening and jumped off the bridge and landed in the creek.

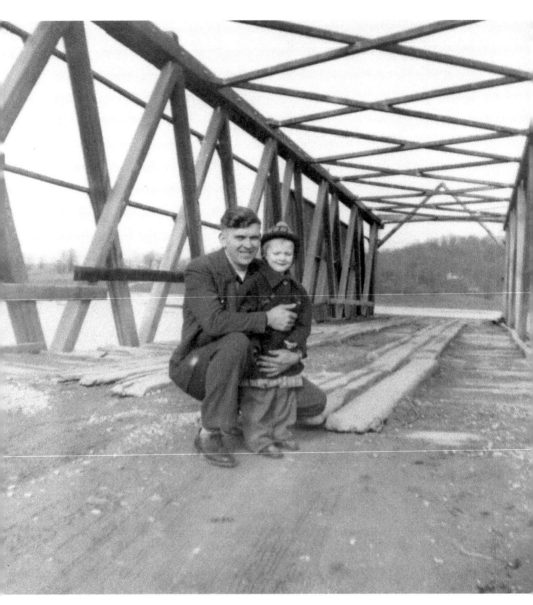

Figure 3.5 Dale McClung collection.

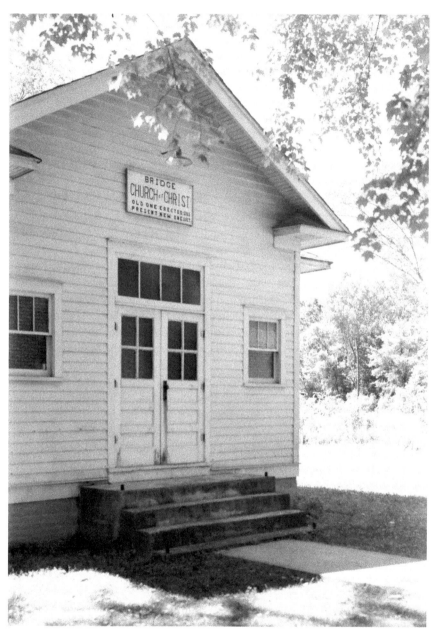

Figure 3.6. Courtesy of the Lilly Library, Indiana University, Bloomington, Indiana.

In figure 3.5, Dale McClung is holding his daughter Brenda (Polley) on what remains of the partially dismantled Church Bridge late in the fall of 1952. The lake is beginning to fill, and the water can be seen in the distance. Half of the siding on the northwestern corner of the bridge is still intact, and the Smith truss is clearly visible in this picture.

Local resident Diane Young remembers that her father, Phillip Lentz, helped build the dam of Lake Lemon; he crossed the bridge every day on his way home from work. The lake began to hold water more quickly than anticipated after hard rains. She said her father always claimed he was the last person to drive across the bridge because the water was up to the bumper on his truck the last time he drove across the lake bottom.

The Bridge Church of Christ faced east at the southwestern corner of the intersection in the road near the bridge. The photo in figure 3.6 was taken July 16, 1946. The trees in the distance are along the edge of Bean Blossom Creek, and John Young Road can faintly be seen in the distance beyond the church. The Bridge Church graveyard was located on a small hill west of the church. A sign on the church above the doors reads, "Bridge Church of Christ, Old One Erected 1881, Present New One 1927." The original building was severely damaged by the flood of 1913, and the flood waters rose so high that the Bible was swept from the rostrum. As the Bean Blossom Valley was cleared for farming, flooding became more of a problem. Floods in the following years damaged the building beyond repair. In 1927 A. W. Harvey designed a new building, which sat on a four-foot-high foundation. It took two months to build; was completed on October 2, 1927, at a cost of $1,100; and was paid for by the time the work was finished. The church was moved as part of the Lake Lemon project.

The Bridge Church graveyard was located on the small hill at the right side of the picture in figure 3.7 but was moved to Tunnel Road when Lake Lemon was built. This photo was taken looking northwest toward where the dam is built. Bean Blossom Creek is beyond the trees on the right, and John Young Road is barely visible at the lower right corner of the photo. A few gravestones can be seen in the distance near the trees at the right side of the photo.

The church was the last property in the lake bottom to be purchased by the City of Bloomington. Most buildings in the lake bottom had already been purchased and demolished, but the congregation wanted their building moved. After negotiations with the City of Bloomington, a deal was struck, and the building was moved to its current location on Tunnel Road. In figure 3.8, the church is resting on large timbers, and some of the foundation has been removed in

Facing top, Figure 3.7. Martha Belle Young collection.

Facing bottom, Figure 3.8. Dale McClung collection.

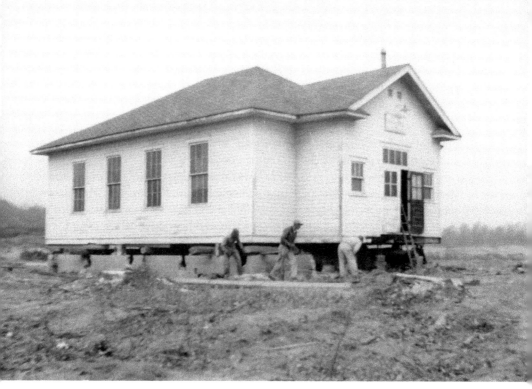

21

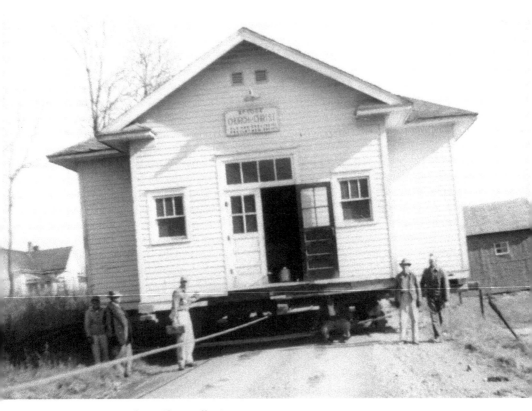

Figure 3.9. Dale McClung collection.

preparation for the move. Fisherman who use underwater scanning sonar can still see the remains of the church foundation.

Figure 3.9 shows the church after it was at the top of the hill on Tunnel Road. Dale McClung remembers the building being moved. "The man in charge was John Gray, who was eighty-seven years old at the time. A wrecker was used to move the church. The building was moved on wooden rollers. When it got to the foot of the hill they found the wrecker didn't have enough power. This is where the church sat after the first day's move."

Diane Young remembers the church sitting in the front yard of the old Riddle farmhouse. Her family lived there while her father helped construct the dam, and they moved out about April 1953 after the lake began filling. Since the wrecker didn't have enough power to pull the church up the hill, a larger machine had to be brought in.

Dale said, "A Cat D6 dozer was brought in from Charles Hartsock's sawmill up the road. It had enough power to pull the church up the hill, but the road became too narrow in a couple of places and the dozer was used to widen the road." Charles's son Maurice and Maurice's brother-in-law Wayne Pontius owned the dozer.

Maurice Hartsock remembers,

Our dozer was a 1948 D6 Caterpillar. We used it around the sawmill and Wayne operated it a little more than I did. John Gray was the "engineer" in charge of moving the church. He could move houses and buildings using wooden rollers. We used the dozer to move the church when the wrecker didn't have enough power. The dozer had a winch, and we would use the cable to pull the church without moving dozer. It was a pretty big, heavy machine, so it didn't move. We used the blade to widen the road in a few places. We never thought about the road being too narrow.

The church sat in the road overnight in front of Dale McClung's house after the move up the hill on the second day of the relocation. When Dale was asked what motorists did when they encountered the church in the middle of the road, he replied with a chuckle, "They drove around it! There wasn't much traffic back then." The road was mostly flat the rest of the way, and after a total of about four days of moving, the church was placed on its new foundation on Tunnel Road. Once the church was set on its new foundation, the only damage found was some cracked plaster in the corners.

Today the church has a brick front entrance, and a rear portion has been added. The original part in the middle with the four tall windows is still easily discernible.

4

CUTRIGHT BRIDGE

1880–1963

The Cutright Bridge was named in honor of the Cutright family, who had settled around the area where the bridge was built. Homer and Billy Howard owned and ran a water-powered sawmill that was once in operation near the bridge. This bridge is listed as 14-53-05 and crossed Salt Creek in Section 4, Township 7 North, Range 1 East, Monroe County. The single-span bridge was 144 feet long, 16 feet wide, and 14 feet tall with a 3-foot overhang at each end. In later years a sheet metal roof was placed over the original wooden shingles. The structure sat on cut-stone abutments built by Hege & Weaver of Indianapolis, Indiana, and were completed by October 15, 1880. The cost of the abutments was $3.80 per cubic yard of masonry, $0.15 per cubic yard of excavation, and $0.10 per lineal foot of timber in foundation at a total cost of $3,037.70. In 1880 the Smith Bridge Company built and completed the bridge with a Howe truss at a cost of $16.95 per lineal foot for a total cost of $2,440.80. The bridge was used for eighty-three years until it was destroyed by fire in 1963 while a local contractor dismantled it as part of the Monroe Reservoir project.

Local resident Mark Stanger was the foreman over the crew building the causeway at Lake Monroe. He remembers the bridge caught on fire while a group of workers from a lumberyard were dismantling it. The bridge crossed Salt Creek on the east side of the State Highway 446 causeway. The road that crossed the bridge is underwater, and all that remains is an abandoned road in a ravine on the south side of the road that goes to the Cutright launching ramp.

In figure 4.1, the political signs above the south portal in 1960 read "Stuckey for Clerk" and "Duncan for Commissioner," along with a Pepsi "More Bounce to the Ounce" sign.

A unique feature about this bridge, shown in figure 4.2, is the V notch that is cut in the center at the top of the south portal.

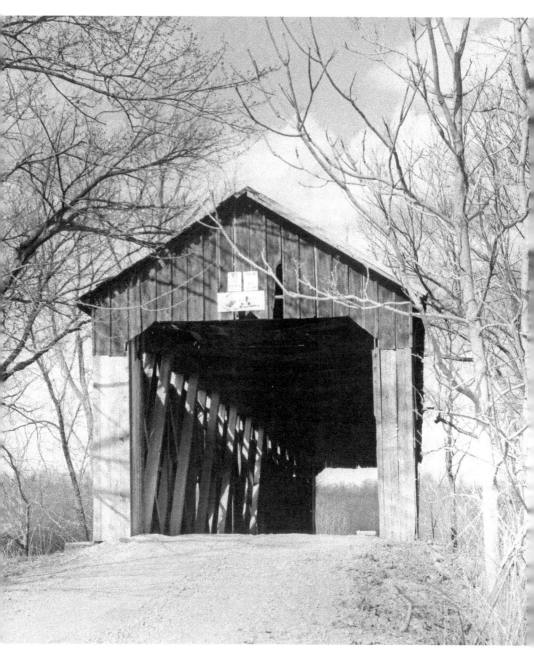

Figure 4.1. National Society for the Preservation of Covered Bridges Archives; photo by Jesse Lunger.

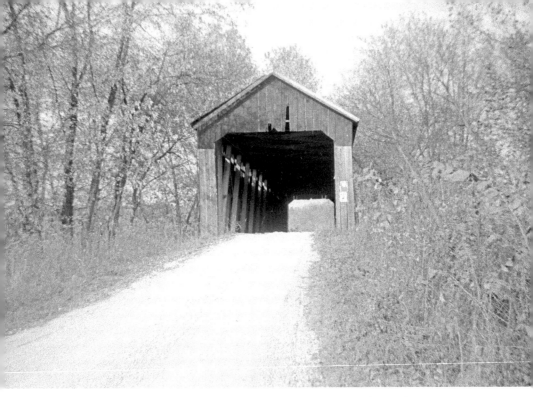

Figure 4.2. National Society for the Preservation of Covered Bridges Archives; photo by Richard Sanders Allen.

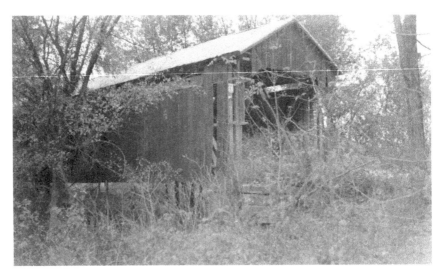

Figure 4.3. Indiana Historical Society, Covered Timber Bridge Committee collection, 1930–1979.

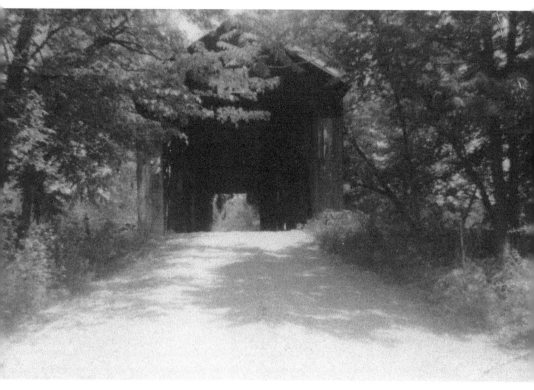

Figure 4.4. Martha Fox collection.

The north portal, shown in figure 4.3, has the same V-notch design.

In nearly all photos of the south portal (fig. 4.2 and 4.4), a Pepsi sign can be seen at the top, like the one in this view from April 1961.

The photos in figures 4.5–7 show some pieces of the Cutright Bridge that were given to me in 2014. A gentleman came up to my covered bridge display at the Children's Farm Festival (Peden Farm) and began looking at the artifacts that I had collected from the different bridges. He told me that he had two large castings from a covered bridge where Lake Monroe is now and that I could have them to add to my collection. He had purchased them from a man who dismantled the bridge. On seeing them, I knew these were from a Howe truss. The Cutright, Fairfax, and Goodman Bridges had Howe trusses, and the Cutright Bridge is the only one of these that was dismantled. The castings weigh about seventy-five pounds each and are eighteen inches wide and fourteen inches tall. The iron tension rods are 1 ¾ inches in diameter and would have extended from the top to the bottom of the bridge, which had a height of fourteen feet. The rods would have

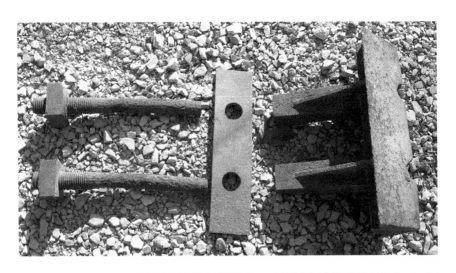

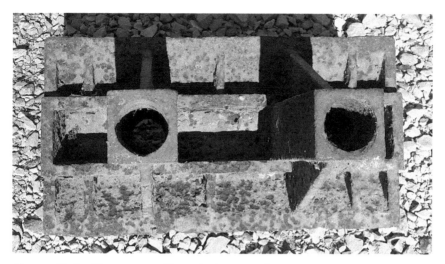

Above and facing, Figures 4.5–4.7. Photos by Jeremy Boshears.

weighed about 120 pounds each, and the square nuts used on these rods would have required a large 3 ½-inch wrench, definitely not a wrench you would find in a typical hardware store! The photos in these figures show one of the castings with pieces of the rods and the steel plate that was placed on the opposite side of the chord.

5

DOLAN BRIDGE

1878–1927

The Dolan Bridge, also known as Grays Mill, crossed Bean Blossom Creek in Section 2, Township 9 North, Range 1 West, Monroe County, and was listed as 14-53-10. The Western Bridge Company of Fort Wayne, Indiana, built the 110-foot-long bridge and completed it by September 1, 1878. Using a Howe-type truss, the company built the bridge for $1,650.00, at a cost of $15.00 per lineal foot. The structure sat on cut-stone abutments that Hege & Defrees of Indianapolis, Indiana, had built. The company completed the abutments by July 8, 1878, at a cost of $2,500.00. The Dolan Bridge was in use for forty-nine years until an iron bridge replaced it in 1927. On the 1895 map this road is listed as North Pike, which became part of the Dixie Highway in 1915; today it is known as Old State Highway 37. The covered bridge was located on the west side of the current concrete bridge.

Figure 5.1 shows the south portal on April 9, 1926.

The Dolan Bridge and the iron bridge that replaced it were photographed on June 22, 1927 (fig. 5.2). This view is looking north at what is now Old State Highway 37. All of the siding on the bridge has been removed, but it is still in use, as evidenced by the car that has just exited the bridge driving north. The iron bridge was in service until 1994, when it was replaced by a concrete bridge. Figure 5.2 clearly shows four men working on the iron bridge. The concrete mixer at the corner of the bridge is a Rex mixer that the Chain Belt Company of Milwaukee, Wisconsin, manufactured. *Rex* is Latin for *king*, and a three-horsepower gasoline engine powered these early units.

Old State Highway 37 is now located on the right side of the road in figure 5.3. The house in the distance is still lived in today but is surrounded by trees, making it hard to see.

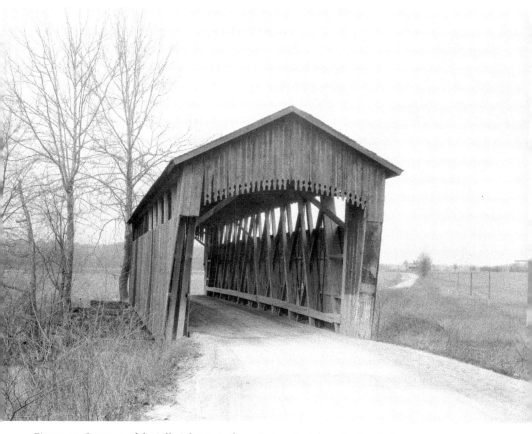

Figure 5.1. Courtesy of the Lilly Library, Indiana University, Bloomington, Indiana.

Each bridge builder had a unique style of trim and decoration, but the Dolan Bridge (fig. 5.4) had probably the most uniquely decorated portals of all the bridges in Monroe County.

Figure 5.5 gives the impression that the bridge has fallen down, but the photographer turned the camera while taking a photo of the west side of the Dolan Bridge on January 21, 1925.

The Howe truss design can be seen in this interior view of the east side of the Dolan Bridge (fig. 5.6). The diagonal wooden timbers are under compression, and the vertical iron rods are under tension.

Figure 5.7 features a view from underneath the Dolan Bridge, taken January 21, 1925, and shows a gentleman standing below the north abutment.

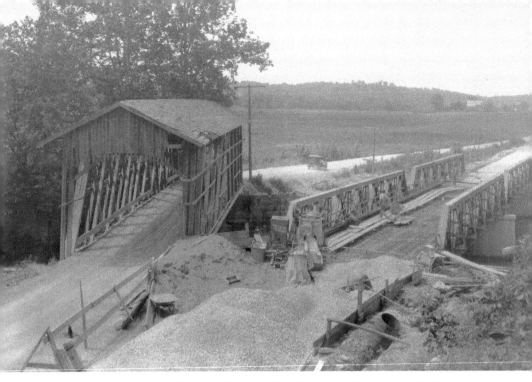

Figure 5.2. Courtesy of the Lilly Library, Indiana University, Bloomington, Indiana.

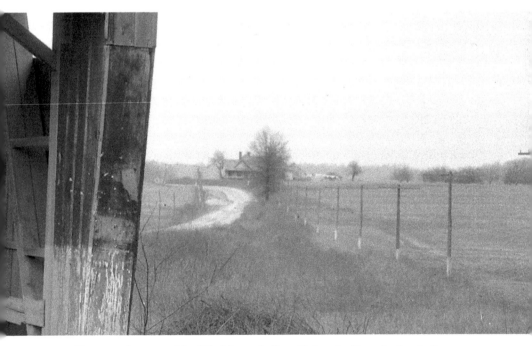

Figure 5.3. Courtesy of the Lilly Library, Indiana University, Bloomington, Indiana.

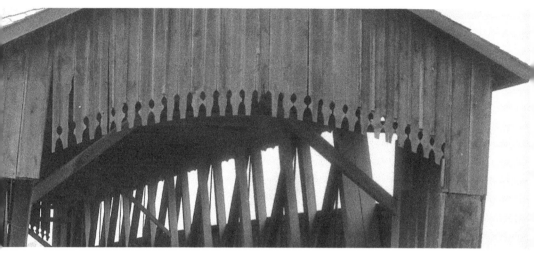

Figure 5.4. Courtesy of the Lilly Library, Indiana University, Bloomington, Indiana.

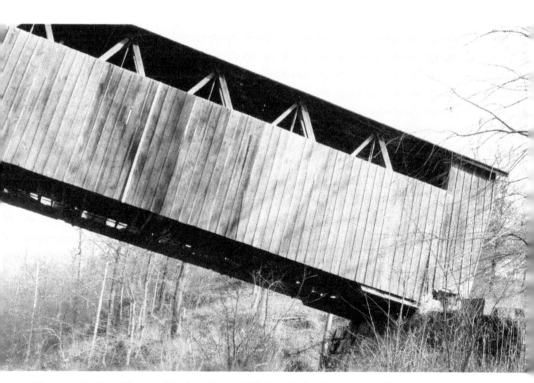

Figure 5.5. Indiana Historical Society, Covered Timber Bridge Committee collection, 1930–1979.

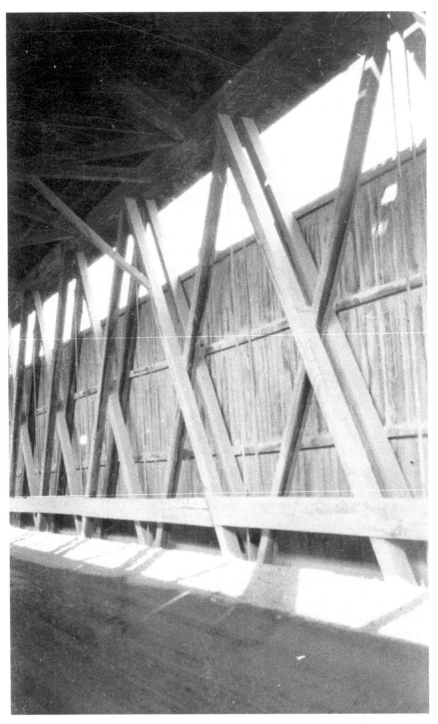

Figure 5.6. Indiana Historical Society, Covered Timber Bridge Committee collection, 1930–1979.

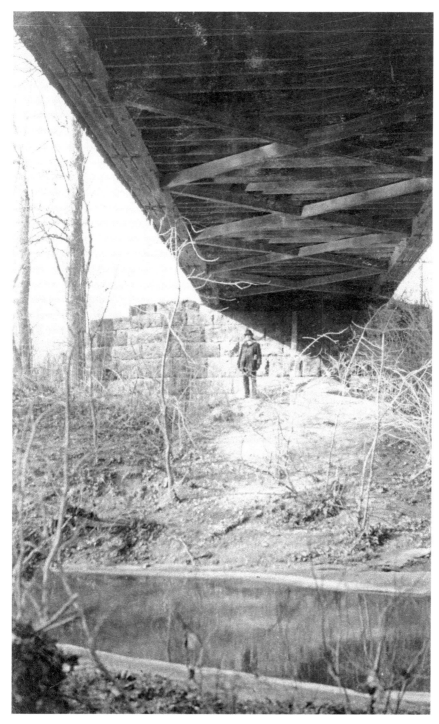

Figure 5.7. Indiana Historical Society, Covered Timber Bridge Committee collection, 1930–1979.

Figure 5.8. Photo by Jeremy Boshears.

Figure 5.8 was taken looking north. Today Old State Road 37 has a concrete bridge over Bean Blossom Creek. The covered bridge was on the left side of this bridge, and nothing from the abutments are left, as they were removed when this bridge was built. The tall pine trees in the distance surround the house shown in figures 5.1 and 5.3.

6

FAIRFAX BRIDGE

1879–1963

The Fairfax Bridge was located at the south edge of the town of Fairfax, which dates back to 1836. The general store Scarborough & Wilson opened in 1838 and the Helton Gristmill in 1840, which shipped flour and pork downstream on flatboats. Helton also manufactured furniture during the 1840s and 1850s. The mill was located on the south side of Salt Creek just west of the covered bridge location. A post office was in operation from 1837 to 1874. Prior to 1929 an oil well was drilled close to the bridge, but sulfur water was all that was found.

The covered bridge connected Fairfax with Chapel Hill and Harrodsburg, which had a railroad depot. The bridge is listed as 14-53-03 and crossed Salt Creek in Section 35, Township 7 North, Range 1 West, Monroe County. It was 125 feet long, 16 feet wide, and 15 feet tall with a 3-foot overhang at each end. The original wooden-shingle roof was replaced with sheet metal in later years. Fillion & Smith of Bedford, Indiana, built cut-stone abutments for a total cost of $3,671.65. The Smith Bridge Company built the bridge, completing it by September 15, 1879. The company used a Howe truss at a cost of $13.90 per lineal foot, for a total cost of $1,737.50.

In 1963 it was going to be removed as part of the Monroe Reservoir project. Steve Martin remembers that a group of local residents were making arrangements to move the bridge so that it could be saved, but it mysteriously caught on fire in the middle of the night on November 7, 1963, and was burning at both ends when discovered. Some local people always wondered if someone had set the fire intentionally so that the bridge being moved would not delay the reservoir project. The bridge was in use for eighty-four years until it was lost to arson.

The Fairfax Bridge was located on Salt Creek at a place known as Scotts Ferry. This area is just south of what is today known as the Fairfax State Recreation

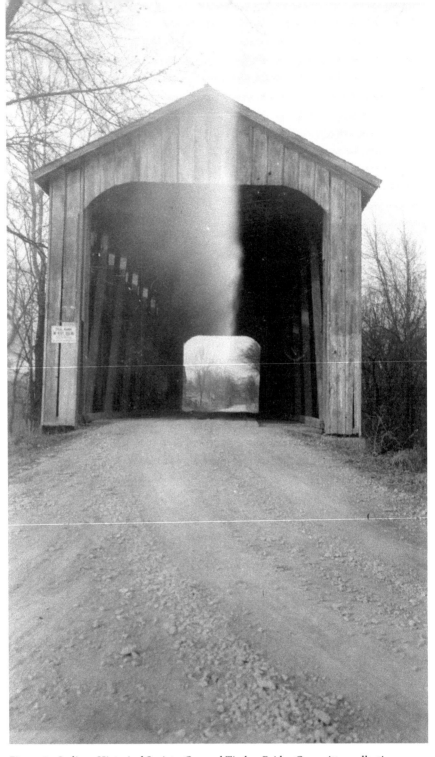

Figure 6.1. Indiana Historical Society, Covered Timber Bridge Committee collection, 1930–1979.

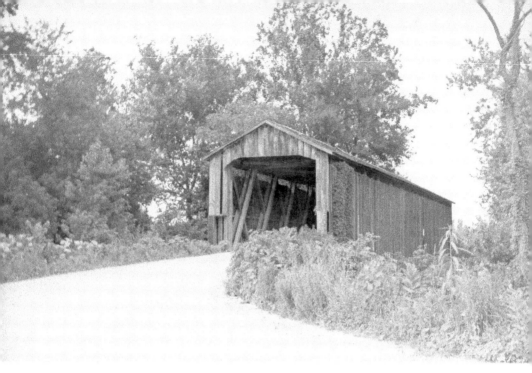

Figure 6.2. Photo courtesy of the Theodore Burr Covered Bridge Resource Center, Oxford, New York.

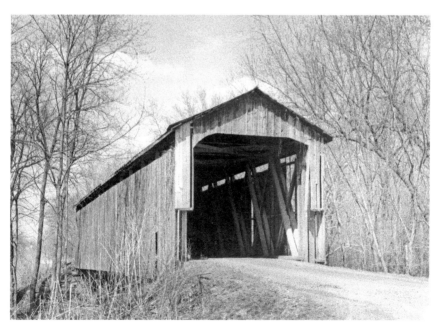

Figure 6.3. National Society for the Preservation of Covered Bridges Archives; photo by Jesse Lunger.

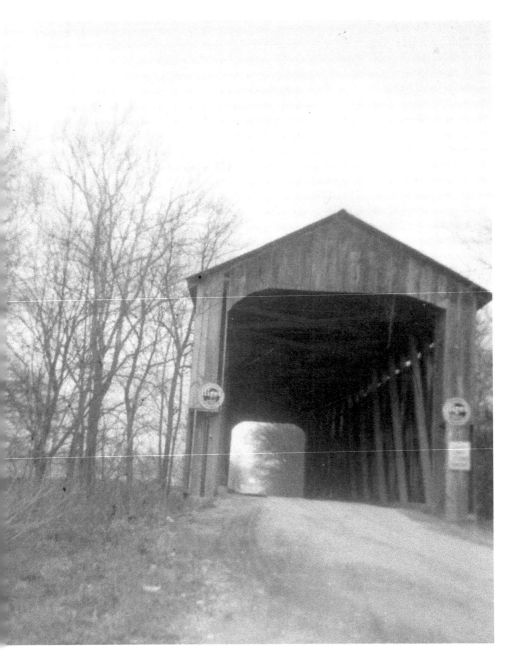

Figure 6.4. Harold Martin collection.

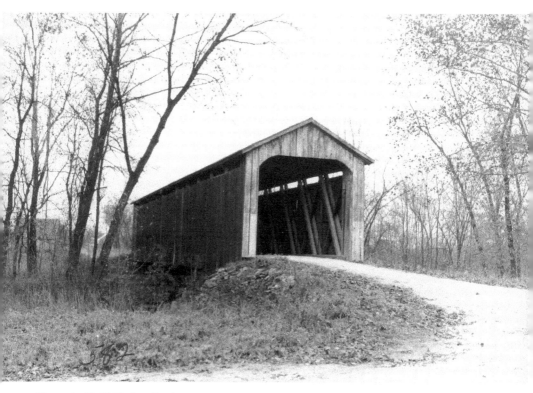

Figure 6.5. Todd Clark collection.

Area. An 1850s plat map shows a reference to a water-powered mill downstream from the covered bridge location.

In figure 6.1, taken on January 13, 1938, a sign at the left side of the south portal says, "Special Warning, No Heavy Hauling."

The road leading to the left in figure 6.2 crossed the Goodman Bridge and went to Harrodsburg; the road leading to the right went to Chapel Hill. Traveling north through the bridge led to Fairfax and on to Mount Ebal.

Figure 6.3 shows a view of the south portal from the early 1960s.

George and Lizzie Cracraft owned the Chapel Hill store and post office, which housed the first telephone in the early 1920s. George was born in 1861 and took over the store and post office in 1887, after his father's death. His father, John Cracraft, opened the store when a town at Chapel Hill was laid out in 1856, but the town never developed into anything more than a few houses.

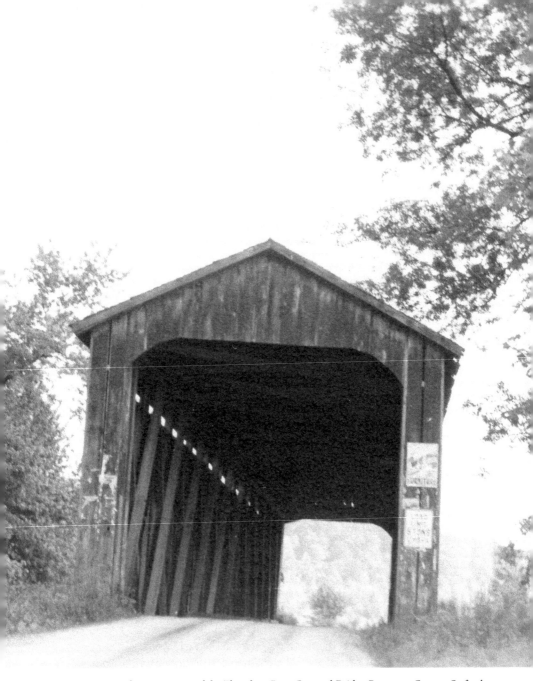

Figure 6.6. Photo courtesy of the Theodore Burr Covered Bridge Resource Center, Oxford, New York.

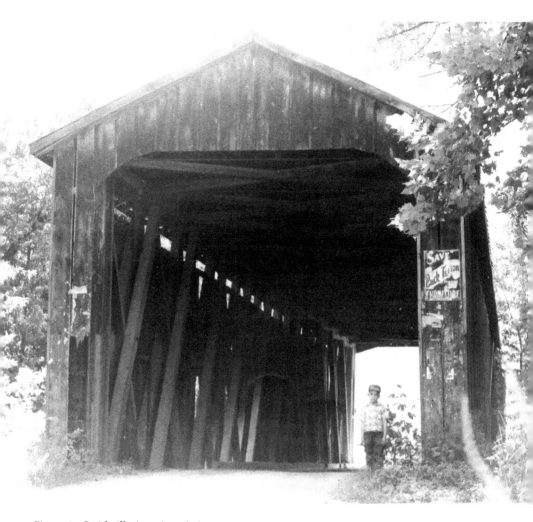

Figure 6.7. Smithville Area Association.

Local resident Harold Martin remembers going to the store when he was about seven or eight years old (1932) and George Cracraft telling him, "I'm the last man still alive that helped build the Fairfax covered bridge."

George and Lizzie lived in a log house next to the store. The store and house were located across the road from where the church in Chapel Hill is today. Both the store and log house have been torn down. George would have been about eighteen years old when he worked on the bridge.

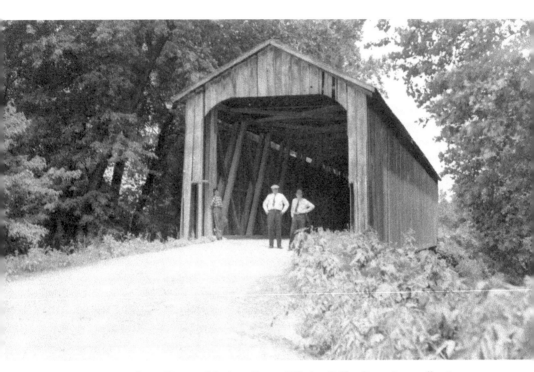

Figure 6.8. Indiana Historical Society, Covered Timber Bridge Committee collection, 1930–1979.

In figure 6.4, Hires Root Beer signs appear on both sides of the south portal of the bridge in the late 1950s. Pharmacist Charles Elmer Hires introduced that root beer in 1876.

In figure 6.5, some buildings are visible beyond the creek on the left side of the bridge in this view of the south portal.

Figure 6.6. shows Buck Lemon Furniture and "Load Limit 5 Tons Gross" signs at the right side of the north portal.

This view of the north portal (fig. 6.7) show a young boy and a "Save at Buck Lemon Furniture" sign. Buck Lemon Furniture was in business until 1998 and had been located in the Hamer-Smith building on the square in Bedford, Indiana, since the 1930s.

In figure 6.8, two men and a boy can be seen in this summertime view of the south portal.

7

GOODMAN BRIDGE

1881–1964

The Goodman Bridge was named for the location that was once known as Goodman Ford but is also sometimes referred to as the Hobart Bridge. The bridge is listed as 14-53-04 and crossed Salt Creek in Section 28, Township 7 North, Range 1 West, Monroe County. The single-span bridge was one hundred feet long with a six-foot overhang at each end, sixteen feet wide, thirteen feet six inches tall, and had a five-ton load limit. A wooden-shingle roof covered this structure that sat on cut-stone abutments that George Weaver of Columbus, Indiana, had built.

Bids were taken for building both the Goodman and Johnson Bridges at the same time. Bidders for building the abutments were Othmar Graf of Bedford, Fillion & Smith of Bedford, and George W. Weaver of Columbus. Weaver won the contract at $3.60 per cubic yard, for a total cost of $5,512.90. Bids for bridge work were made by Thomas A. Hardman of Brookville, Indiana; King Iron Bridge Company of Cleveland, Ohio; Hege & Defrees of Indianapolis, Indiana; the Smith Bridge Company of Toledo, Ohio; the Wrought Iron Bridge Company of Canton, Ohio; the Columbia Bridge Company of Dayton, Ohio; and A. M. Kennedy & Sons of Rushville, Indiana. Thomas A. Hardman of Brookville, Indiana, won the bid at $14.40 per lineal foot, for a total cost of $1,440.00.

Hardman built the bridge in 1881 with a Howe truss, and it was in use for eighty-three years until it was removed in 1964 as part of the Monroe Reservoir project. The bridge crossed Salt Creek about a half mile northwest of where the Lake Monroe dam is today and connected the Salt Creek area with the Harrodsburg railroad depot.

Local resident Harrold Martin remembers the dam being built. He said that the dam was built but not finished and that a lot of rain was forecast for Monroe County. The Army Corps of Engineers and workers were staying at a motel close

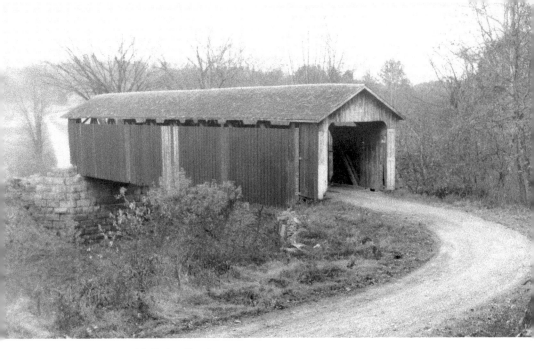

Figure 7.1. Todd Clark collection.

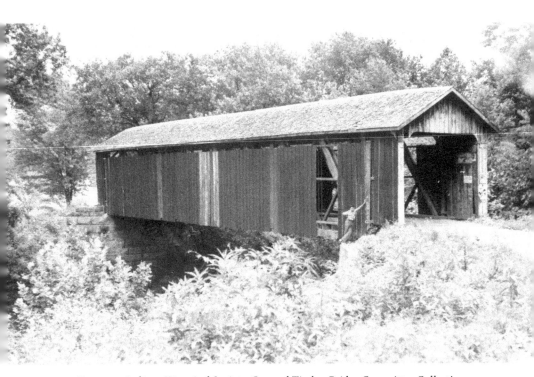

Figure 7.2. Indiana Historical Society, Covered Timber Bridge Committee Collection, 1930–1979.

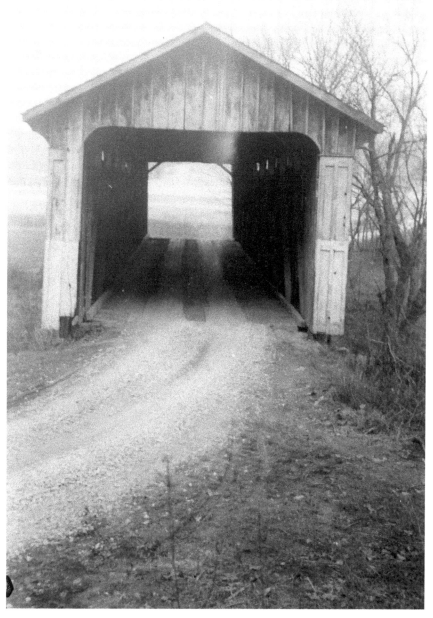

Figure 7.3. Indiana Historical Society, Covered Timber Bridge Committee Collection, 1930–1979.

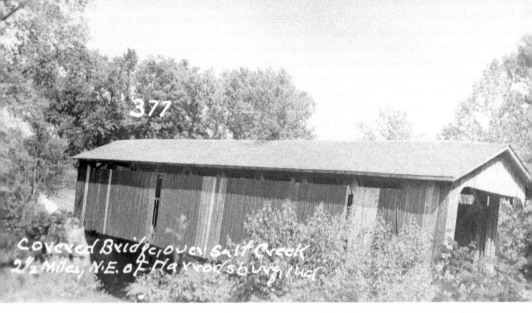

Figure 7.4. Photo courtesy of the Theodore Burr Covered Bridge Resource Center, Oxford, New York.

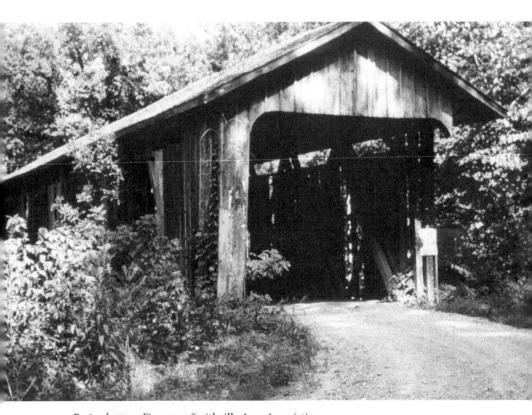

Facing bottom, Figure 7.5. Smithville Area Association.

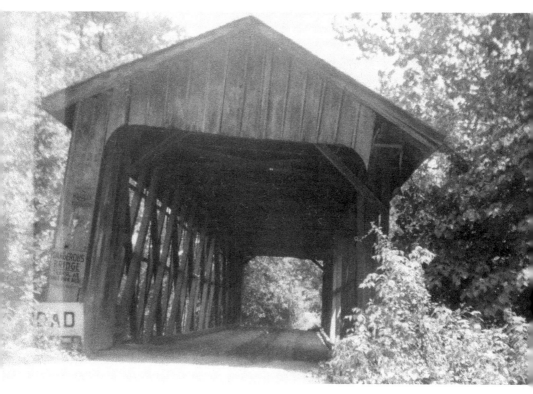

Figure 7.6. Photo courtesy of the Theodore Burr Covered Bridge Resource Center, Oxford, New York.

to the dam, and a group of farmers who had lived in the Salt Creek bottoms went to the motel to tell the Army Corps that they needed to get their equipment to higher ground. The Army Corps replied that their equipment would be fine. Harrold remembers standing on the dam after the rain and looking at all the water that had filled in the lake before it was even planned. All the equipment below the dam was submerged, and the boom of a crane could be seen sticking up from the water. A group of men from the Army Corps were also standing on the dam looking at the flooding.

One them said, "There's a lot more water here than we thought."

A farmer replied, "We tried to tell you that. We've lived here our whole lives. The water gets pretty wild down here when it floods."

Aerial photos of the dam during construction show that the lake had begun to fill but had also flooded below the dam. Equipment that was below the dam can be seen partially submerged.

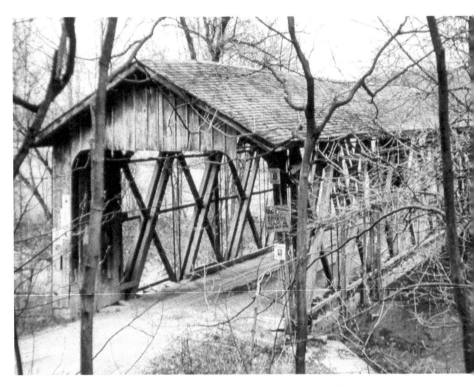

Figure 7.7. Indiana Covered Bridge Society, photo by Arthur Gatewood Jr.

The exact date that the flooding happened is unclear, but the Goodman Bridge was completely submerged for a short period of time. An Indiana Covered Bridge Society newsletter from April 1964 reported that the Goodman Bridge was submerged but still in place. The October 1964 newsletter reported that the water had been lowered and the bridge was visible again. A January 1965 newsletter reported that Harry and Marry Woolley of Richmond, Indiana, drove to Monroe County and photographed the Goodman Bridge on November 1, 1964. They reported that there was very little water in the creek and no water in the lake. Another person visiting the bridge was taking photographs and said that this was the first time that he had ever taken a picture of a covered bridge on the bottom of a lake!

The exact date that the bridge was removed is unclear, but it may have been early 1965 instead of 1964. The January 1965 Indiana Covered Bridge Society newsletter reported that "a news item dated December 3 (1964) stated that bids would be received for removal of 19 bridges in the Monroe Reservoir." All bridges and structures had to be removed by spring, and once the gates were closed, the

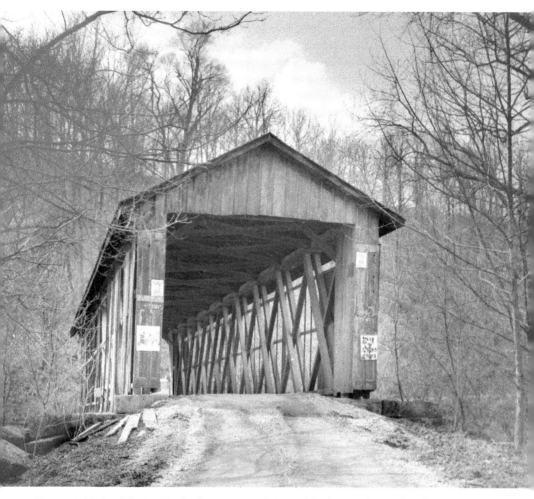

Figure 7.8. National Society for the Preservation of Covered Bridges Archives; photo by Jesse Lunger.

lake would reach summer pool level by May 1965. The local legend is that the Goodman Bridge was pushed off its abutments with bulldozers and burned.

Figure 7.1 shows the west portal of the bridge. Today the Lake Monroe dam is located about a half mile to the right of the bridge.

In figure 7.2, a person stands on the edge of the abutment with a hand on the bridge in this summertime view of the west end of the bridge.

Figure 7.3 shows a view of the west portal, taken on January 13, 1938. The curved corners at the top of the portals help identify this bridge. Looking through

the bridge, one can see the other end has square-cut corners. This detail, visible in photos from the late 1930s, must have been from a siding repair.

In figure 7.4, the right side of the west portal overhang is missing. In later years this part was never repaired. The reason it is missing is unknown, but the road made a sharp turn to the left coming onto the bridge. One can only wonder if a speeding automobile on the crushed-stone road didn't slow down enough to make the turn onto the bridge and crashed into it.

The date of figure 7.5, a photo of the west portal, is unknown, but the bridge is still in use, as evidenced by the "Load Limit 5 Tons Gross" sign on the right side.

In figure 7.6, most of the siding is gone, and the bridge has become weak. A sign on left side of the west portal says, "Dangerous Bridge Travel at Your Own Risk"; a "Road Closed" sign is below it in the weeds.

Figure 7.7 lists Harrodsburg C. B. in the lower right-hand corner, but it is actually the west portal of the Goodman Bridge. The Howe truss can be seen along with a "Dangerous Bridge Travel at Your Own Risk" sign on the right side of the bridge.

In figure 7.8, the east portal is decorated with political signs: "Elect Jim Simpson Commissioner"; "Ray J Hinkle for Commissioner"; "Sutherlin for Clerk"; and "Lentz for Sheriff." An Oasis cigarette sign also says, "Refreshment at its very best." Most photos of the Goodman Bridge are taken from the west side. Today Monroe Dam Road is on the hill in the distance.

8

GOSPORT BRIDGE

1870–1955

The Gosport Bridge crossed the west fork of the White River at a location known as Brownings Ferry. This connected Moon Road in Monroe County with North Street in the town of Gosport. The triple-span bridge is listed as 14-53-14, was 504 feet long with a 10-foot overhang on the Monroe County side, 16 feet wide, and 13 feet tall; it had a 5-ton load limit. Local legend is that the west span (the Gosport side) is thought to have caught on fire around 1885 from the cinders of a passing locomotive. Further research into this span found that it was an open wooden truss and that after fifteen years of service may have become rotten. No definite conclusion can be found as to why it was replaced. In 1885 the Indianapolis Bridge Company built an iron Whipple truss in its place. The Indianapolis Bridge Company was a short-lived business, lasting only from 1883 to 1885.

The *Bloomington Republican Progress* reported February 11, 1885, that "farmers in Monroe County near Gosport have been shut off from that town this winter because the bridge is out on the Owen County side. During the cold snap, however, the people crossed on the ice with their sleighs."

The Smith Bridge Company built the bridge in 1870 with a Smith patent truss, and iron tension rods were added later for strength. The two covered wooden spans had a total length of about 336 feet with a 10-foot overhang at the east end. The span on the Gosport side was originally an open wooden truss. Metal roof caps were placed at the top of the compression timbers on the upper chords for protection from the weather, and iron rods were used for the tension members.

A newspaper article from *Bloomington Republican Progress* on January 17, 1872, reported, "The bridge over the White River at Gosport is completed. It was built by the Smith Bridge Company of Toledo, Ohio. Bean Blossom Township and Owen County can now strike hands. This is the bridge for which the Monroe

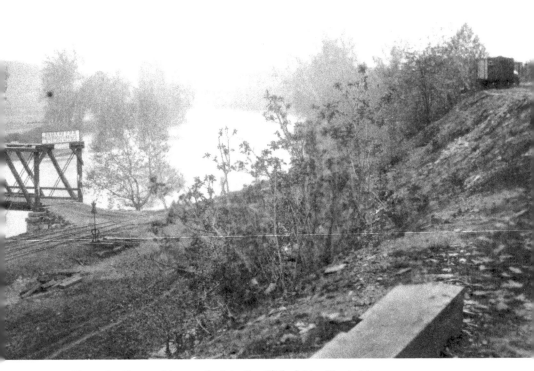

Figure 8.1. Gosport Museum Society, Ten O'Clock Line Treaty Museum.

County commissioners subscribed $4,000." Monroe County Commissioners' records show that three payments were made for the bridge: "First payment of $1,333.33 on August 15, 1872, second payment of $1,333.33 on August 15, 1873, and last payment $1,333.33 on August 15, 1874." It is estimated that the bridge cost nearly $15,000.00 total.

The bridge was used for seventy-nine years until it was closed in 1949 because of weak timbers in the east span. The east span collapsed in the spring of 1955, but residents still used the bridge by climbing a ladder at the pier and walking across the remaining wood and iron span to Gosport. In late October 1955, arson destroyed the center section. Ten firefighters plunged into the river when the structure collapsed while fighting the blaze. Assistant fire chief Bert Dittemore Jr. was killed when he was pinned under a cable and drowned, and eight others were injured. A $1,000 reward was offered for clues. About a week after the fire, three young boys admitted to setting the fire as a Halloween prank.

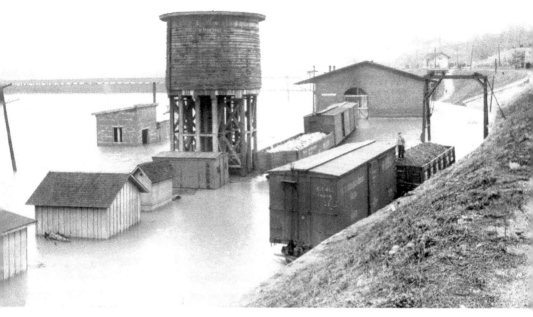

Figure 8.2. Gosport Museum Society, Ten O'Clock Line Treaty Museum.

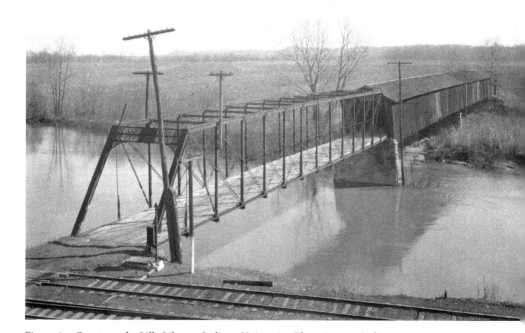

Figure 8.3. Courtesy, the Lilly Library, Indiana University, Bloomington, Indiana.

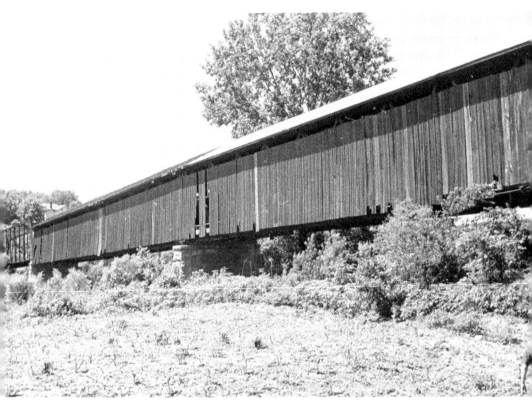

Figure 8.4. Indiana Historical Society, Covered Timber Bridge Committee collection, 1930–1979.

The Monroe County Commissioners' records show the bridge being built in 1870, the sign that was placed on the bridge shows 1871, and the newspaper article about the bridge being completed weren't written until 1872. After the bridge had been in service for several years, maintenance became somewhat of a problem. Monroe and Owen Counties debated over who should do the maintenance, whom the bridge really belonged to, and whom it benefited. Owen County

Facing top, Figure 8.5. Indiana Historical Society, Covered Timber Bridge Committee collection, 1930–1979.

Facing bottom, Figure 8.6. Indiana Historical Society, Covered Timber Bridge Committee collection, 1930–1979.

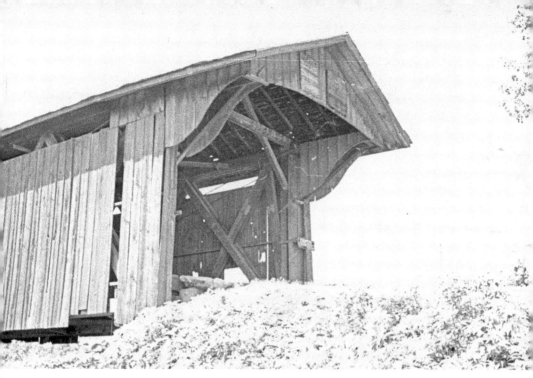

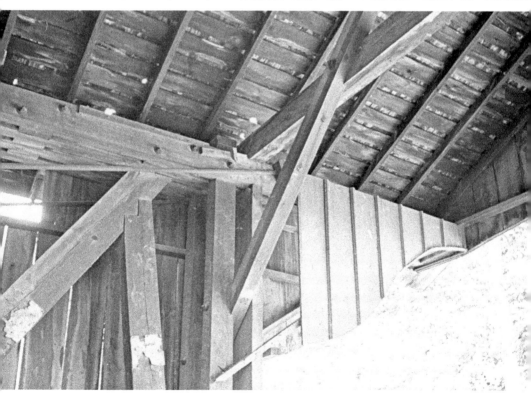

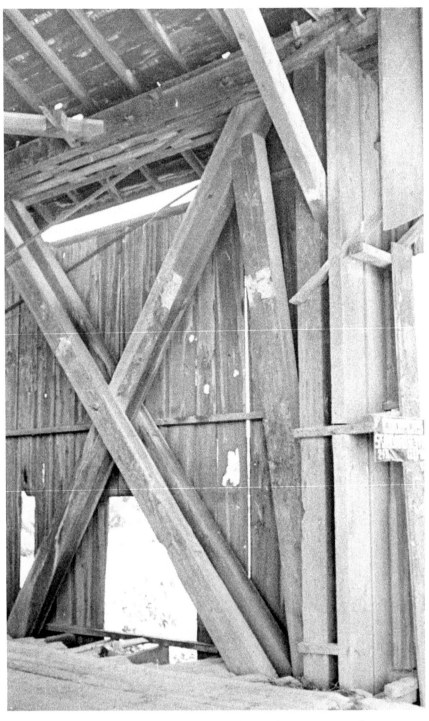

Figure 8.7. Indiana Historical Society, Covered Timber Bridge Committee collection, 1930–1979.

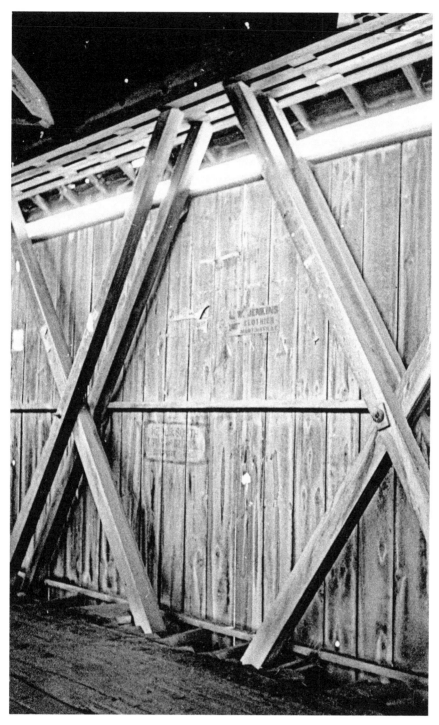

Figure 8.8. Indiana Historical Society, Covered Timber Bridge Committee collection, 1930–1979.

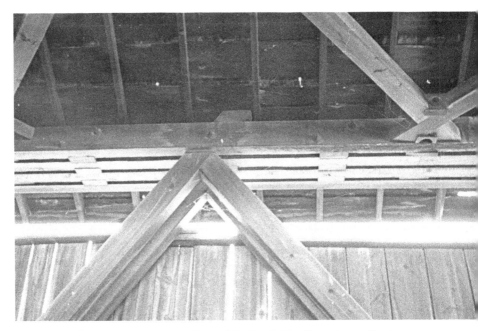

Figure 8.9. Indiana Historical Society, Covered Timber Bridge Committee collection, 1930–1979.

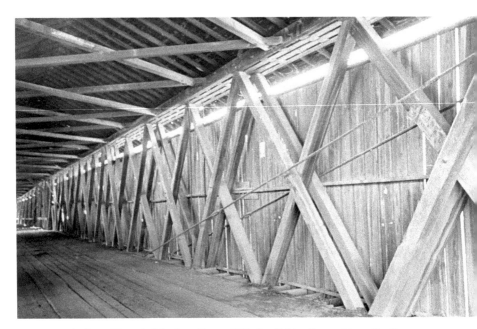

Figure 8.10. Indiana Historical Society, Covered Timber Bridge Committee collection, 1930–1979.

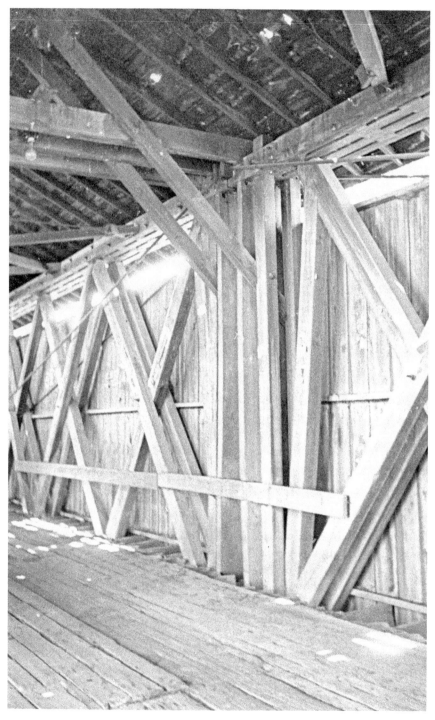

Figure 8.11. Indiana Historical Society, Covered Timber Bridge Committee collection, 1930–1979.

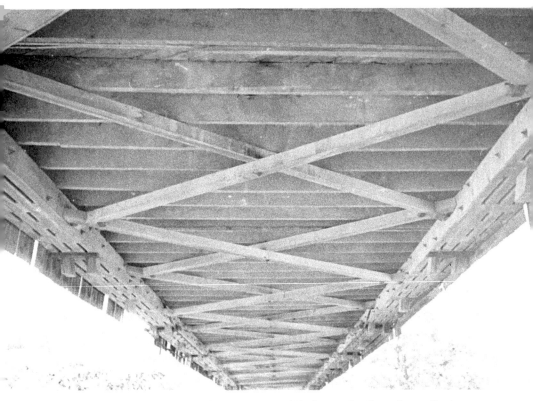

Figure 8.12. Indiana Historical Society, Covered Timber Bridge Committee collection, 1930–1979.

claimed that Monroe County residents wanted access to the town of Gosport and the railroad. Monroe County claimed that Owen County residents wanted access to Monroe County, but at the time the bridge was built, there wasn't much of anything but farm ground on the Monroe County side.

The first known photos of the bridge were taken about 1880–1883. From this point on it is interesting to look at how the White River has moved around and has gone from wide to narrow and back. Today the river is very close to the Gosport abutment and wide enough that both piers are in the river. Some photos show a narrow river under only one section of the bridge, and that has moved around and been under each span at one time. Others show a wide river that was almost against the Monroe County abutment and trees growing under the iron span.

Figure 8.13. Indiana Historical Society, Covered Timber Bridge Committee collection, 1930–1979.

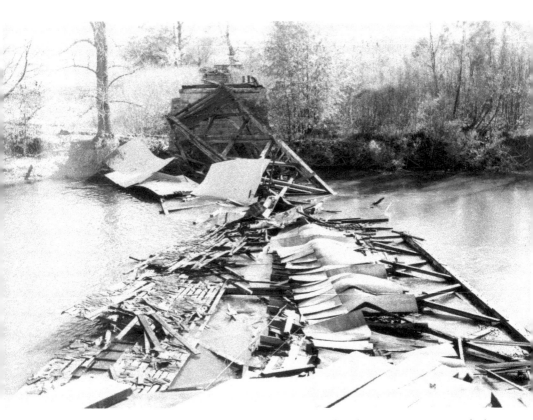

Figure 8.14. Photo courtesy of the Theodore Burr Covered Bridge Resource Center, Oxford, New York.

During the flood of 1913, the water level rose so high that water was up on some of the flooring of the iron span of the bridge. During this flood it is estimated that the flood waters rose about 19.5 feet above flood stage around Indianapolis.

The photo in figure 8.1, taken about 1880–1883, is probably the rarest picture of any in this book. The original open-sided wooden truss that was used on the Gosport side of the bridge can be seen at the left side of the photo. The sign above the bridge says, "Built by the Smith Bridge Company of Toledo Ohio 1871."

The flood of 1913 surrounded all the railroad buildings and equipment below the town of Gosport. In figure 8.2, the boxcar is marked C.I.&L. for the Chicago, Indianapolis & Louisville Railway, which in later years was known as the Monon Railroad. In the distance the covered bridge can be seen with water up to the floor.

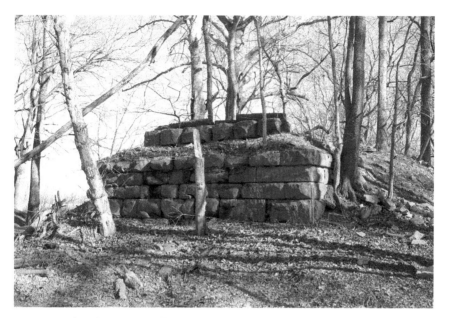

Figure 8.15. Photo by Jeremy Boshears.

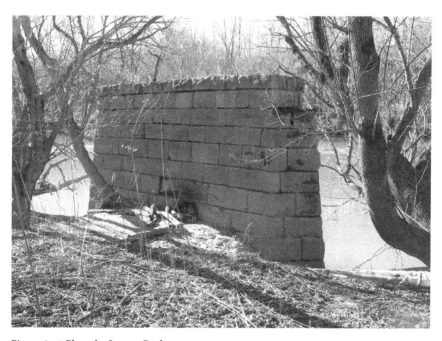

Figure 8.16. Photo by Jeremy Boshears.

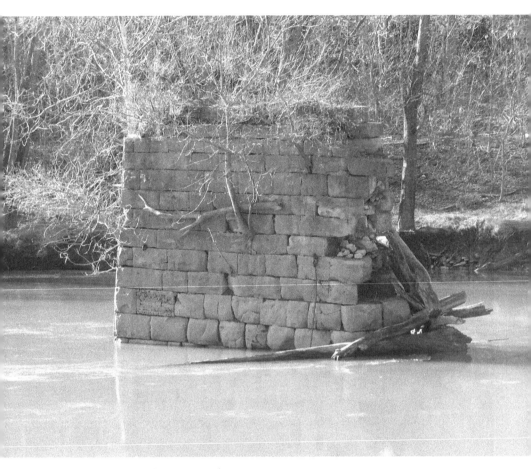

Figure 8.17. Photo by Jeremy Boshears.

Figure 8.3 shows the iron Whipple truss span that the Indianapolis Bridge Company built in 1885, photographed on February 16, 1926. At the ends of the bridge across the top were decorative scroll designs, with two signs in the center. The upper sign said, "Indianapolis Bridge Company," and the lower one had the names of the commissioners at the time the bridge was built. The signs cannot be clearly seen in this photo, but they are the solid rectangular portion at the top of the bridge on the end.

Figure 8.4 shows the south side of the bridge on June 8, 1941. Today the White River is just beyond the pier at the center of the photo and goes all the way to the Gosport abutment.

The Gosport Bridge had a unique overhang (fig. 8.5).

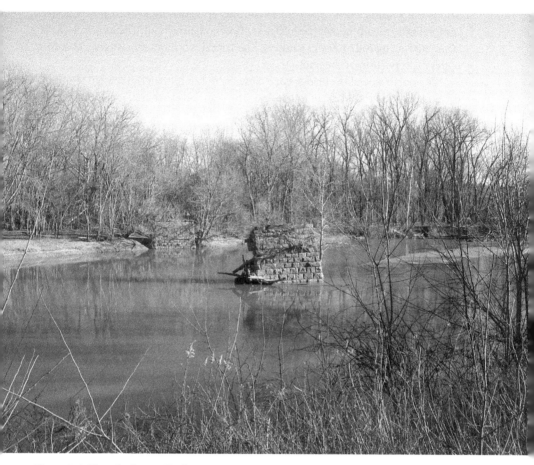

Figure 8.18. Photo by Jeremy Boshears.

Figure 8.6 shows the inside of the overhang; the angled brace notched into the diagonal in the side panel is typical of a Smith truss.

Figure 8.7 shows a view of the inside of the south portal, similar to figure 8.6. A sign that says "Cooper's Standard Service, Gosport" is nailed to the bridge at the right side of the photo.

Figure 8.8 shows an "L. W. Jenkins Clothier, Martinsville" sign attached to the siding. The word *clothier* could refer to a tailor, a clothing store, or a place that sells cloth. This photo is midspan of one of the sections.

The top chord of the side panel and lateral wind bracing are visible in figure 8.9. The diagonal timber extending upward from the lower left passes through the upper chord. This timber is under tension, meaning that the forces of the

bridge are pulling on it. The timber coming up from the lower right is under compression, meaning that the bridge is always pushing on it. The upper chord is laminated using four rows of timbers. The lateral wind bracing intersects at the upper right portion of the photo.

The north side of the bridge has a Case Farm Equipment sign nailed to one of the braces at the right side of figure 8.10. The iron rods that angle from the upper right down to the flooring are not part of the original structure.

Figure 8.11 shows the junction of the two covered spans. A very unique feature of this bridge is the incandescent lighting, which is visible at the top left of the photo. This was the only bridge in Monroe County that had electric lighting. An issue of the *Gosport Evening World* from August 6, 1914, lists "light Gosport Bridge $25.00" as one of Monroe County's yearly expenses.

Figure 8.12 was taken below the first covered span, showing the structure under the floor looking toward Gosport.

Figure 8.13 shows an iron rod on the north corner of the Monroe County abutment, installed to keep the bridge from floating away during flooding, such as in the flood of 1913. These iron rods were mounted on all of the piers and abutments of the Gosport Bridge.

Figure 8.14 shows all that remained of the center span after arson destroyed it in late October 1955 as viewed from the iron span (Gosport side).

The bridge had been closed in 1949 due to weak timbers in the east span. People still used the bridge for walking, and occasionally a car would drive across, although there were barricades. In October 1953 the *Bloomington Daily Herald Telephone* reported that a farmer in Monroe County said that the eastern span looked like a sway-backed mule. The eastern span collapsed in January 1955, and the pile of rubble was intentionally burned to clean up the mess. Local residents placed a ladder at the center span and still walked across, as evidenced by the ladder at the right side of the pier in figure 8.14. Then in late October 1955, arson destroyed the center span. The iron span was later dismantled for safety reasons, though it is unclear if it was scrapped or moved to a new location.

The abutments and piers for the Gosport Bridge are still standing, though Mother Nature is starting to take its toll on the stone (fig. 8.15). Moon Road, which leads to the Monroe County abutment, is still open. The road is no longer maintained close to the bridge, and during some parts of the year, a four-wheel drive is needed to get through the rough and muddy places. Carving on the south corner of the Monroe County abutment can still be seen today. Originally both corners were carved, but the north corner of the abutment has deteriorated.

The pier in figure 8.16 is on the Monroe County side of the river and is still holding together quite well. Large steel hooks are mounted in the pier just above the ground. These hooks were used to anchor the bridge down so that it didn't float away in extremely high waters, such as during the flood of 1913. The upstream

side of the pier at the right side of the photo is tapered to a point to help break up ice so that it would float around the pier.

The pier located in the river (fig. 8.17) is beginning to crumble and will eventually fall into the water. One of the rods that anchored the bridge is still hanging on a hook at the right side. This picture was taken from the Monroe County side.

In figure 8.18, looking from the Gosport side on the abandoned Monon Railroad right-of-way, one can see both piers, but trees obscure the abutment on the Monroe County side.

9

HARRODSBURG BRIDGE

1874–1949

The Harrodsburg Bridge was located on the main road north of the town of Harrodsburg. An 1895 map lists this as the Bedford Road, but today it is known as Gore Road. The bridge is listed as 14-53-07 and crossed Clear Creek in Section 29, Township 7 North, Range 1 West, Monroe County. The single-span bridge was eighty-two feet long with a three-foot overhang at each end, and the specifications from the 1874 commissioners' records are as follows: "Smith Truss, 16′ wide, 15′-3″ high, floor joists 2 ½″ thick, 12″ wide, and 20″ long of oak; plank is 2 ½″ thick, 6″ wide, laid diagonally and of oak; all timbers of white pine. Siding is 1″ x 12″ planed on one side and covered with moulded batten, roof of pine shingles, laid 5 ½″ to the weather. Painted with 2 coats of mineral paint with oil." The Smith Bridge Company built the bridge in 1874 and received $1,586.00 for the construction, at a cost of $19.00 per foot. James Russell & Company built the cut-stone abutments for $2,683.00 at a cost of $4.25 per cubic yard. The bridge was rated at a five-ton load limit, and iron tension rods were added sometime after 1938 for increased strength.

One local resident remembers that in the 1940s, the bridge was becoming very weak and that some people feared it might collapse with a school bus full of children. The bridge was in use for seventy-five years, but on September 9, 1949, the lower chords of the bridge were deliberately cut with a saw, and the structure fell into Clear Creek. Local residents had made several attempts to the get the county to repair the bridge. The neighborhood wanted to keep the bridge but didn't want anyone to get hurt or killed if the bridge collapsed while people were crossing it.

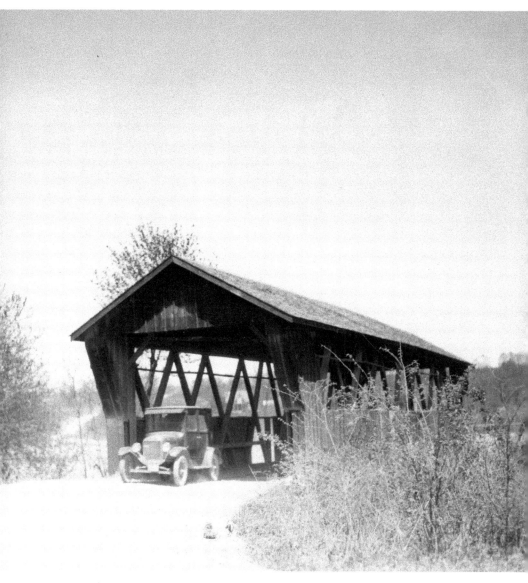

Figure 9.1. Indiana Historical Society, Covered Timber Bridge Committee collection, 1930–1979.

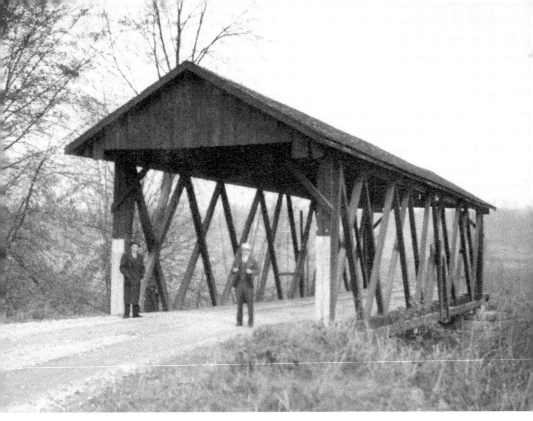

Figure 9.2. Indiana Historical Society, Covered Timber Bridge Committee collection, 1930–1979.

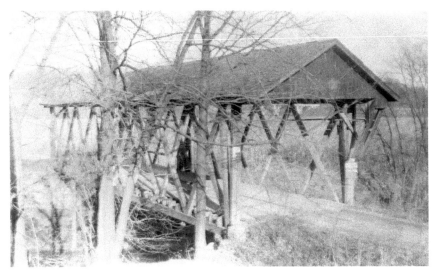

Figure 9.3. Indiana Historical Society, Covered Timber Bridge Committee collection, 1930–1979.

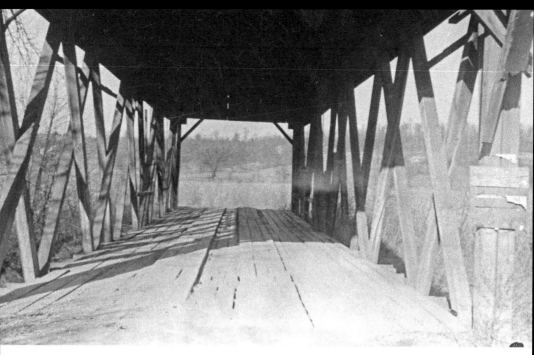

Figure 9.4. Indiana Historical Society, Covered Timber Bridge Committee collection, 1930–1979.

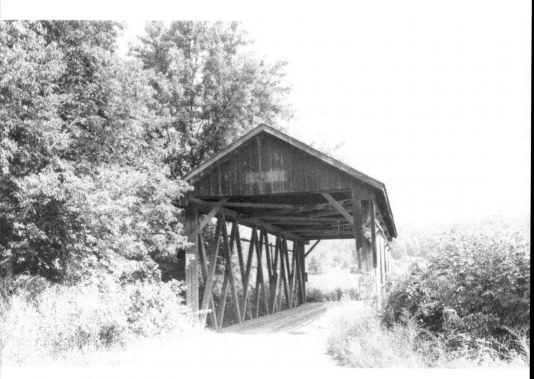

Figure 9.5. Todd Clark collection.

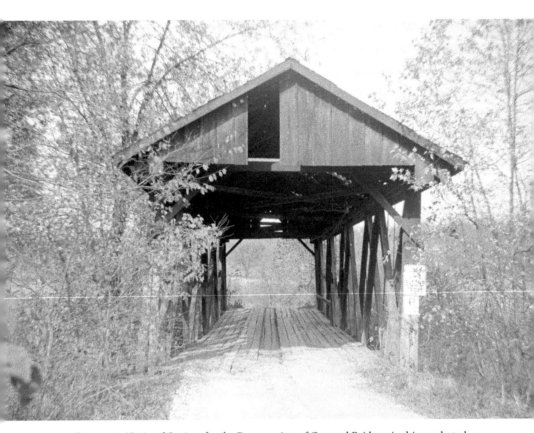

Figure 9.6. National Society for the Preservation of Covered Bridges Archives; photo by Richard Sanders Allen.

The town of Harrodsburg dates back to 1835 and at one time had many thriving businesses. In 1837 Alexander Buchanan laid out the town and named it New Jane after his wife. The name was later changed to Harrodsburg, most likely after Buchanan's hometown of Harrodsburg, Kentucky. The Chambers Mill was located on the north side of Clear Creek, just east of the bridge location on an 1856 map. An 1895 map shows that Clear Creek Pike led south out of Bloomington and transitioned into Bedford Road just north of the covered bridge. The bridge

Facing top, Figure 9.7. National Society for the Preservation of Covered Bridges Archives; photo by Richard Sanders Allen.

Facing bottom, Figure 9.8. Photo by Jeremy Boshears.

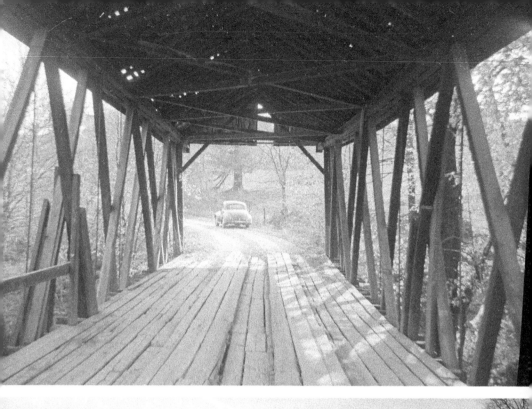

Figure 9.9. Photo by Jeremy Boshears.

carried travelers of Bedford Road for many years until it was bypassed by the Dixie Highway, which today is known as Old Highway 37.

Most photos of the Harrodsburg Bridge show it without siding, but figure 9.1, taken in 1928, shows that the bridge did have siding at one time. The siding appears to go only halfway up on the bridge but did go higher at one time. The Harrodsburg and Church Bridges were built at the same time and have nearly identical portal designs. The house that can be seen through the bridge is still there today.

The date of this view of the Harrodsburg Bridge south portal (fig. 9.2) is unknown, but all the siding is missing. This is how the bridge looked until it was lost in 1949.

Figure 9.10. Photo by Jeremy Boshears.

In figure 9.3, the Old Highway 37 Bridge can be seen through the covered bridge just below the roof on January 13, 1938.

The photo in figure 9.4 was taken looking north on January 13, 1938. All of the siding is missing from the bridge, and in eleven years the bridge would gone.

In figure 9.5, a sign on the right side of the south portal says, "Bridge Unsafe for Heavy Load"; this was prior to the iron tension rods being added. A light, discolored rectangle at the center top of the portal can be seen. Monroe County Commissioners' records show that in 1874 the county placed a sign on the portal that said, "One Dollar Fine for Riding or Driving on This Bridge Faster Than a Walk." It is unclear whether the discolored spot is from that sign or another one; none of the known photos show any type of a sign.

The date of this photo of the south portal (fig. 9.6) is unknown, but the bridge has iron tension rods, indicating sometime after 1938. A "Load Limit 5 Tons Gross" sign is on the right side of the bridge.

Figure 9.7 shows a view from inside the bridge, looking south, with visible vertical iron rods.

Figure 9.8 shows the concrete bridge on Gore Road, where the Harrodsburg Bridge was located. This view is looking south.

The stones along the creek at the northwest corner of the bridge (fig. 9.9) are from the abutments of the covered bridge. Some of the covered bridge is still submerged in Clear Creek and can be seen at certain times of the year, though it has washed downstream from its original location.

Figure 9.10 shows the house on Gore Road that can be seen in the photo in figure 9.1.

10

JOHNSON BRIDGE

1881–1964

The Johnson Bridge was also called the Johnston Bridge, but in later years most local residents called it the Bell Bridge, after the Bell family who lived nearby. The bridge is listed as 14-53-02 and crossed Bean Blossom Creek in Section 8, Township 9 North, Range 1 West, Monroe County. This single-span bridge was one hundred feet long with a seven-foot overhang at each end, fifteen feet wide, and thirteen feet six inches tall; it had a five-ton load limit and a wooden-shingle roof.

Bids were taken at the same time for building both the Goodman and Johnson Bridges. Bidders for building the abutments were Othmar Graf of Bedford, Fillion & Smith of Bedford, and George W. Weaver of Columbus. Weaver built the cut-stone abutments for $3.60 a cubic yard, for a total cost of $2,347.25. Bids for bridge work were made by Thomas A. Hardman of Brookville, Indiana; King Iron Bridge Company of Cleveland, Ohio; Hege & Defrees of Indianapolis, Indiana; Smith Bridge Company of Toledo, Ohio; Wrought Iron Bridge Company of Canton, Ohio; Columbia Bridge Company of Dayton, Ohio; and A. M. Kennedy & Sons of Rushville, Indiana. Thomas A. Hardman of Brookville, Indiana, won the bid at $14.40 per lineal foot, for a total cost of $1,440.00. Hardman built the bridge in 1881 using a Howe truss, and it was used until 1964, when it was replaced with a modern bridge.

Local resident Robert Naylor remembers that his father, Paul Naylor, was awakened in the middle of the night by the barking of his dogs. When his father looked out the window, he could see that the bridge was on fire. He called the fire department, and they were able to put out the fire before the bridge was destroyed. Some repairs were made, and it was still used for a few years until the summer of 1964, when it was replaced.

The July 1964 Indiana Covered Bridge Society newsletter reported that the April society meeting was held at the Indiana University Memorial Union. At the

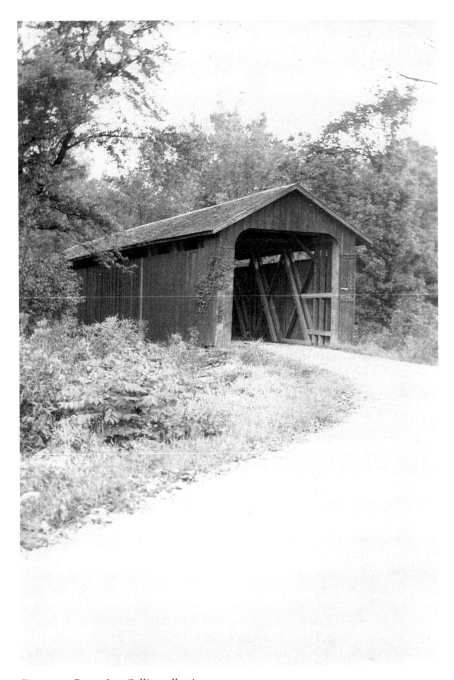

Figure 10.1. Bettye Lou Collier collection.

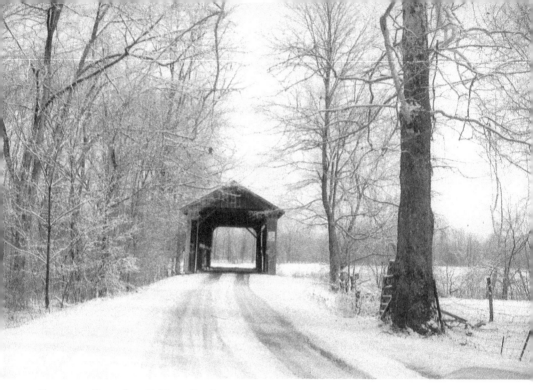

Figure 10.2. Bettye Lou Collier collection.

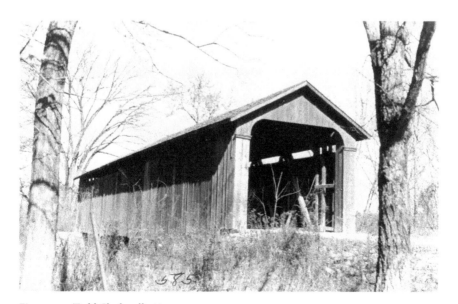

Figure 10.3. Todd Clark collection.

meeting, the Town of Ellettsville and Indiana University expressed interest in moving the bridge. The cost of moving it to Ellettsville was too high, and Indiana University wanted a shorter bridge, so in the end it was demolished. The Johnson Bridge was located where the concrete bridge on Kinser Pike crosses Bean Blossom Creek, just west of State Highway 37. Highway 37 was in the process of being converted to Interstate 69 at the time this book was written, and a new concrete bridge was built.

A summertime view of the north portal (fig. 10.1) clearly shows the Howe truss.

A snow-covered road leads to the south portal in this wintertime photo (fig. 10.2).

These views of the south portal (fig. 10.1–3) brought back memories for local resident Dale McClung. He talked about how these bridges weren't just used for travel and were many times community gathering places. He remembered groups of people getting together and having dances on the bridge. Someone would play music or have a radio playing in a nearby car. Everyone would dance and have a good time, and if a car came down the road, frequently the travelers would stop and join in the dance. He said they would dance for a little while; then those who had been there before would step back, let them pass by, and go back to dancing. You never knew who you would meet at these old bridges. There were always people fishing or swimming when the weather was nice. It was also not uncommon to find some livestock taking shelter in these bridges when it stormed.

Figures 10.4 (taken March 26, 1948) and 10.5 show J&M Feed and Implement signs on both ends of the bridge. Kenny Jacobs and George Mitchell owned the local John Deere dealership in Bloomington during the late 1950s and early 1960s.

The Howe truss can be clearly seen in this view of the north portal (fig. 10.6).

Vines covered the northeast corner of the bridge in this summertime view from the early 1960s (fig. 10.7).

The pieces in these photos (fig. 10.8–9) are from the Johnson covered bridge. I found some of them by accident in the summer of 2014 when I stopped at the former location of the Johnson Bridge. My original intention was to find a piece of stone from the old bridge abutment, but the pieces strewn across the creek bank were too large to move without some type of heavy equipment. The creek

Facing top, Figure 10.4. Photo courtesy of the Theodore Burr Covered Bridge Resource Center, Oxford, New York.

Facing bottom, Figure 10.5. National Society for the Preservation of Covered Bridges Archives; photo by Jesse Lunger.

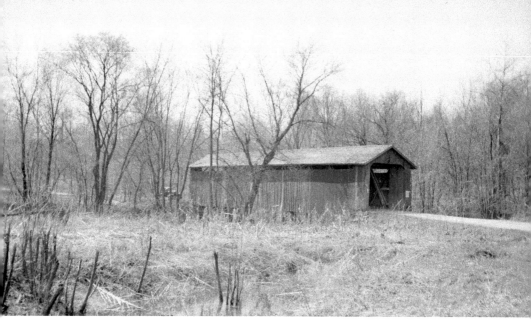

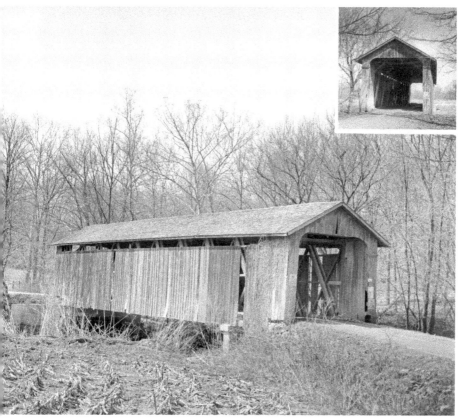

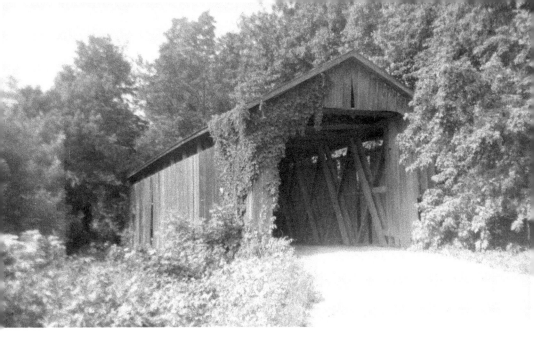

Figure 10.6. Photo courtesy of the Theodore Burr Covered Bridge Resource Center, Oxford, New York.

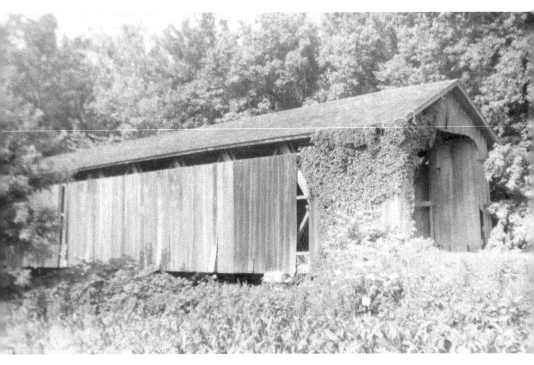

Figure 10.7. Photo courtesy of the Theodore Burr Covered Bridge Resource Center, Oxford, New York.

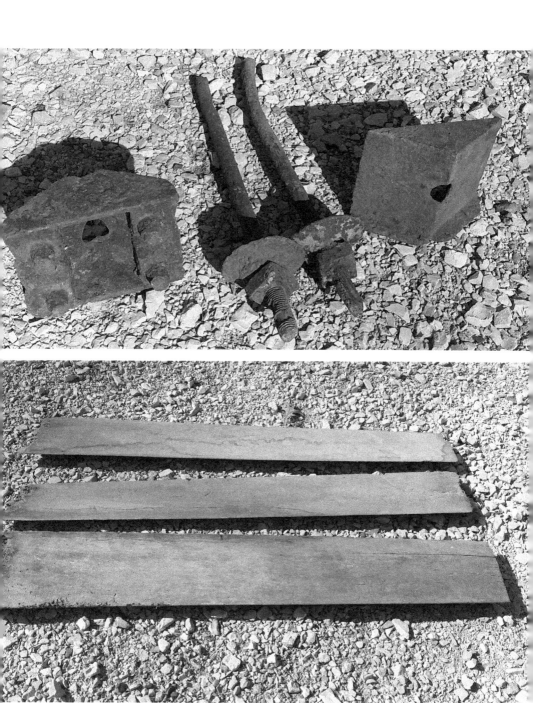

Figures 10.8 and 10.9. Photos by Jeremy Boshears.

Figure 10.10. Photo by Jeremy Boshears.

was very low due to the lack of rain, and when I looked in the water, I saw a steel rod with a square nut just under the surface. I put my hand in the water, pulled up on it, and saw a triangle-shaped casting hanging on the rod. Knowing this was a piece from the old bridge, I pulled harder, but it was stuck under several years of mud and debris and wouldn't budge. With a little help from my father, a chain, and a winch, we were able to pull all of the rod (more than sixteen feet long) out of the mud. Once home, I cut the rod so that the pieces could be displayed.

In 2016 I returned to look for a piece of stone from the abutment, as a new bridge was being put in as part of the I-69 project. The abutment stones were broken into smaller pieces from the equipment that had been working, and I was

able to retrieve one. A gentleman living in the house next to the bridge asked what I was doing, and I told him about my project. He said that in his barn were a few boards from the old covered bridge and that I could have them to add to my collection.

Figure 10.10 shows the bridge on Kinser Pike that replaced the Johnson Bridge, looking north. This bridge has since been replaced as part of the I-69 project.

11

JUDAH BRIDGE

1884–1947

The Judah Bridge, also sometimes called the Judy Bridge, was named for the Judah gristmill. In later years it was sometimes referenced as the Lost Bridge because of its remote location. The bridge is listed as 14-54-09 and crossed the northeast branch of Salt Creek in Section 34, Township 8 North, Range 1 East, Monroe County. The single-span bridge was 120 feet long and had a wooden-shingle roof.

Records show that the bridge was built in 1884, but the date above the portal shows 1885. The Kennedy Brothers used a Burr arch truss to build the bridge. After sixty-two years of service, the bridge was badly deteriorated, and the road was semiabandoned. Bloomington contractor Edwin Bennett purchased the bridge from the county for $500 and dismantled it in the winter of 1946 and spring of 1947.

The Judah Bridge got its name from a gristmill that was located about two hundred yards downstream. Brothers Francis and Morris Judah operated the water-powered gristmill. Morris lived in a house near the mill and also served as a doctor for people in the area. The Judah Bridge was located on the north side of a ridge that is northeast of the Cutright boat launching ramp.

On March 11, 1884, Monroe County Commissioners' records show a petition for a bridge across Salt Creek on the Brownstown and Bloomington Roads near Judah's mill, and on August 1, 1884, a contract was let for the Judah and Nancy Jane Bridges.

The *Bloomington Republican Progress* reported August 22, 1884, that "Mr. Kennedy of Rushville has secured the contract for building the two bridges which were let on Tuesday of last week. They are to be built over Salt Creek, one at the Judah mill, old Strain mill, and the other at the Nancy Jane Chambers ford. The

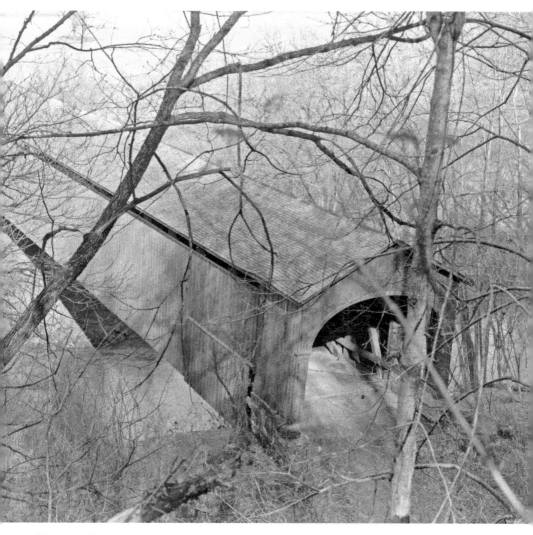

Figure 11.1. Ron Branson, CountyHistory.com.

stone work for the first mentioned bridge was awarded to James S. Williams, and Peter Fillion of Lawrence County secured the stone work at Chambers' ford."

Monroe County Commissioners' records show the following:

On August 14, 1884, a stonework contract was let to James S. Williams at $4.80 per yard. In total he was paid $2,474.00 for the abutments, which were completed in November.

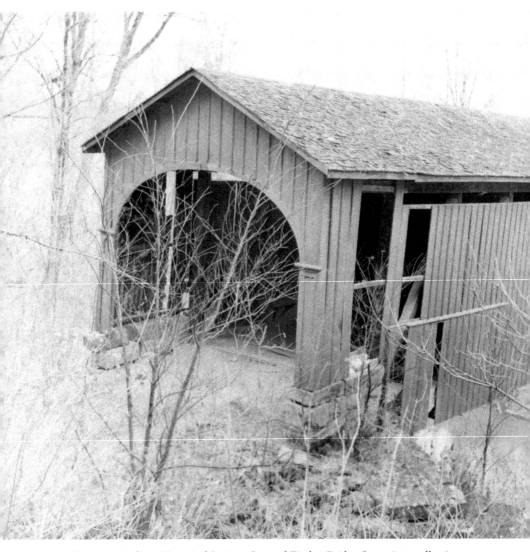

Figure 11.2. Indiana Historical Society, Covered Timber Bridge Committee collection, 1930–1979.

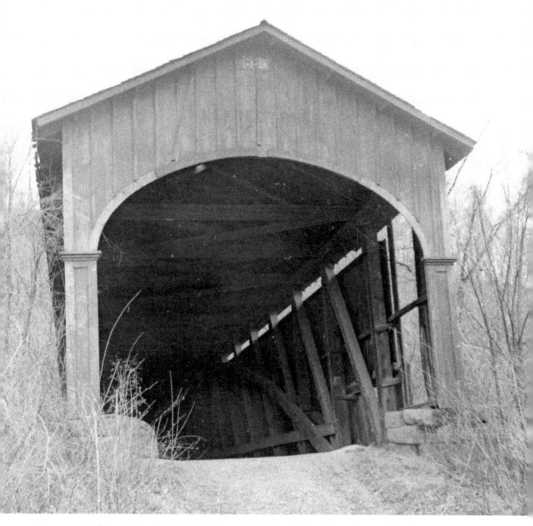

Figure 11.3. Indiana Historical Society, Covered Timber Bridge Committee collection, 1930–1979.

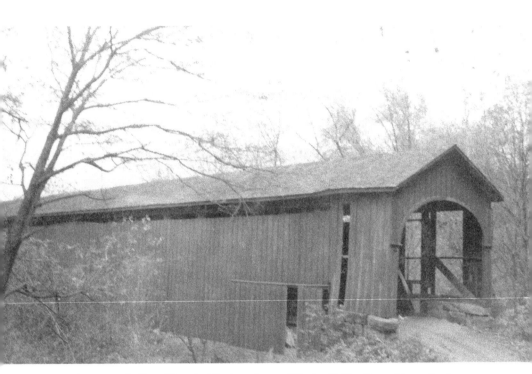

Figure 11.4. Indiana Historical Society, Covered Timber Bridge Committee collection, 1930–1979.

(Local legend is that the stone for the abutments was quarried from the steep hill on the south side of the bridge. There is still a large depression in the hill above where the bridge was located.)

The Kennedy Brothers were paid a total of $5,820.00 for the bridges erected across Salt Creek at Judah's Mill and Chambers Ford. The Judah Bridge cost about $2,609.00 and the Nancy Jane about $3211.00.

George Stream was paid $99.00 and Jacob Chambers $2.00 for work on the approaches to Salt Creek Bridge at Judah's mill.

D. B. Judah was paid $5.00 for timber for the Salt Creek Bridge at Judah's mill.

Facing top, Figure 11.5. Courtesy of the Lilly Library, Indiana University, Bloomington, Indiana.

Facing bottom, Figure 11.6. Indiana Historical Society, Water-Powered Mills Committee collection, circa 1840–1983.

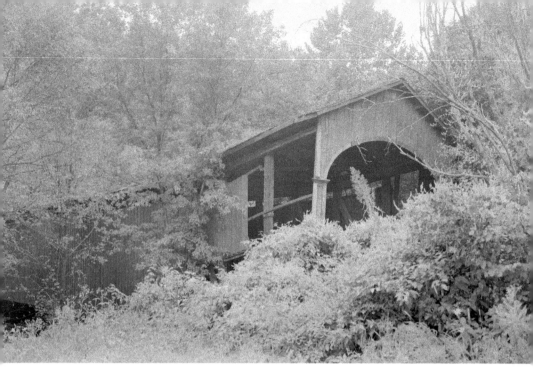

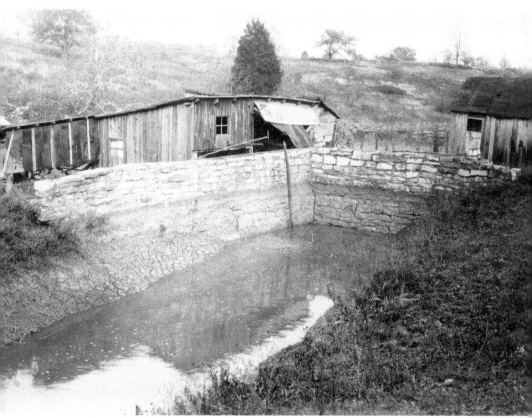

The abutments from the bridge are still underwater in Lake Monroe, and local resident Dan Wagoner remembers standing on them when the lake was very low during a drought in the 1980s.

Figure 11.1, taken in March 1938, shows the view looking down from the ridge on the south side of the bridge.

A few missing boards can be seen in this view of the south portal, taken in 1939 (fig. 11.2).

This view of the north portal (fig. 11.3), taken in 1939, shows the Burr arch truss. "1885, Built by Kennedy Bros" is painted at the top of the portal.

This view of the south portal in figure 11.4 is what travelers would see as they approached the bridge. The road leading to the bridge was at the base of a steep hillside and made a sharp left turn onto the bridge.

Figure 11.5 shows the Judah Bridge as viewed from the north side of the creek September 9, 1945. Some of the siding is missing, and the bridge has only about two years left before it will be dismantled.

Judah's mill, shown in figure 11.6 in a photo taken on November 3, 1926, was located downstream from the Judah Bridge. A plat map of Salt Creek Township shows it as being in service as far back as 1851 and having been listed as the Boles Mill.

The *Bloomington Saturday Courier* reported August 5, 1882, that "our Township (Salt Creek) can now boast of having first class grist mills, Judah Brothers, proprietors. I hear that they are doing a thriving business."

12

McMILLAN BRIDGE

1871–1976

The McMillan Bridge was a bridge of many names. Listed as the Stine Bridge on the 1895 map, it was also called the Millikan Bridge and got this name because of the Millikan Sawmill, owned by Jacob Millikan, on the north side of the creek. Millikan petitioned for the construction of a bridge across the ford because wagons kept getting stuck in the mud. The name Milligan also appears in the commissioners' records and eventually was changed to McMillan, which is how the bridge is listed in most books. In later years many local residents knew it as the Williams Bridge. Wayne and Ruby Williams lived on a farm located on the south side of the creek, and Ruby's father, M. C. McNeely, helped with the construction of the covered bridge when he was nineteen years old.

This bridge is listed as 14-53-01 and crossed Bean Blossom Creek in Section 30, Township 10 North, Range 1 West, Monroe County. The single-span bridge was 115 feet long with a 5-foot overhang on each end and was 12 feet 6 inches wide and 12 feet 6 inches tall. A shingle roof covered this structure, which sat on cut-stone abutments and had a load limit of five tons. The Smith Bridge Company built it in 1871 with a Smith patent truss for a total cost of $2,646.80. Monroe County Commissioners' records show that Andrew Parks built abutments for the bridge for $475.00, which he completed by September 1, 1871. The Smith Bridge Company quoted the bridge at $17.00 per lineal foot, and the company completed the bridge on or before November 1, 1871. Monroe County agreed to pay the Smith Bridge Company one year later plus 6 percent interest to see if the bridge would hold up. If the bridge failed, the company was to remove it.

A commissioners' report dated June 5, 1879, shows that the bridge had not been receiving proper maintenance and bolts were coming loose, causing the upper and lower chords to become misaligned. Iron tension rods were added to help strengthen the bridge, which led some people to believe that it was a Howe truss

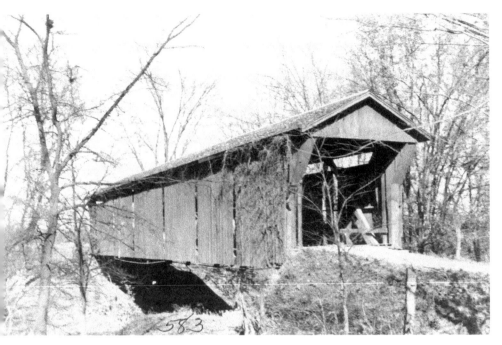

Figure 12.1. Todd Clark collection.

design. The exact date the rods were added is unknown, but it may have been af-
ter the 1879 report. Commissioners had originally decided to build an iron bridge
at this location but rescinded this decision on September 8, 1871, one day after
signing the contract with Smith to build the covered bridge.

The bridge was used mainly by local residents and in the late 1960s was in
need of repairs. Mayor John H. Hooker Jr. suggested moving the bridge to Griffy
Creek as part of a historic restoration area. In 1970 a restoration project was com-
pleted on the bridge. The restoration was estimated at $14,000, but the final cost
was $20,000. The McMillan Bridge stood for 105 years until the evening of June
29, 1976, when it was destroyed by arson.

Local resident Joe Peden remembers crossing the bridge with his tractor and
hay wagons. He said there was a *bump-bump* sound as each of the wagons came
onto the bridge. He listened and counted the *bump-bump* sounds to make sure all
the hay wagons were still attached to his tractor as he crossed the bridge.

This was the last covered bridge in Monroe County. The abutments of the
McMillan Bridge are still visible today a short distance from where Maple Grove
Road North meets with Delap Road, and farmers still use Old Maple Grove Road
on the north side of the bridge to access their fields.

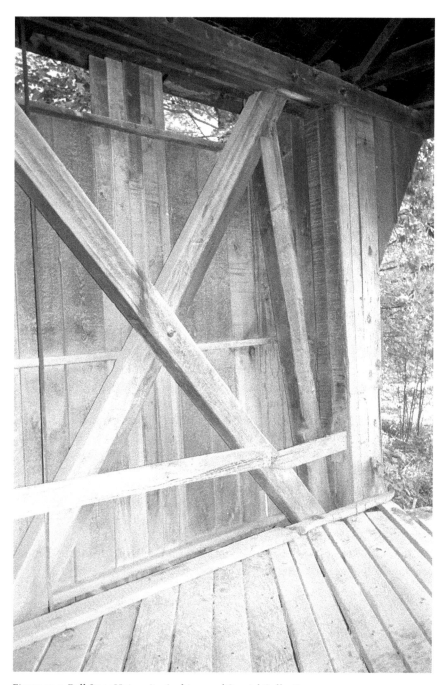

Figure 12.2. Ball State University Archives and Special Collections.

Though Monroe County didn't have any covered bridges for about four decades, that changed in 2018 when construction began on a new covered bridge over Bean Blossom Creek, near where the McMillan once stood. In 1885 the Kennedy Brothers built the Cedar Ford Bridge near Shelbyville, Indiana. It was in use until 1975, when it was removed so that a new bridge could be installed, at which point it was put in storage. It was originally located north of Shelbyville, but the new location is upstream from the McMillan, and the road leading to the new bridge has been realigned on the south side. At the time this book was written, surveying for the new bridge site had just begun in the early spring of 2018.

Figure 12.1, taken in the 1940s, shows the southwest corner.

The interior view in figure 12.2 shows the diagonal pattern of the boards on the flooring. The slightly angled timber that is notched into the other diagonal timber is typical in a Smith truss bridge. The vertical iron rod is not part of the original bridge, and it causes some people to mistake the bridge for a Howe truss.

Figure 12.3 also shows the inside of the north end of the bridge. An "artist" has drawn a couple of smiling faces on the weatherboarding of the bridge at the center right of the picture. The upper face looks like a smiling boy winking his right eye, signed with the initials GA, and the lower picture is a smiling girl with curly hair.

In figure 12.4, a "Nominate Mark S. Stanger for County Auditor" sign decorates the north portal of the bridge in the 1960s. The original petition in the Monroe County Commissioners' records for this bridge includes the name James Stanger, who was the great-uncle of Mark S. Stanger. Larry Stanger remembers the night that the bridge burned. At the time he was fire chief for the Bloomington Township Fire Department. When he heard the call on his radio ("The old covered bridge on Maple Grove Road is on fire"), he looked out the north window of his residence and could see the fire. Living close to the bridge, he was the first firefighter on the scene, and other firefighters arrived a short time later. "I was standing there when she went in the creek," said Stanger.

Figure 12.5 shows a winter view of the south portal before the 1970 restoration.

The drawing in figure 12.6 shows some of the problems and repairs to be made to the bridge during the 1970 restoration.

The outline of a person can be seen inside the bridge in figure 12.7, as viewed from the south portal after the 1970 restoration.

Facing top, Figure 12.3. Ball State University Archives and Special Collections.

Facing bottom, Figure 12.4. National Society for the Preservation of Covered Bridges Archives; photo by Jesse Lunger.

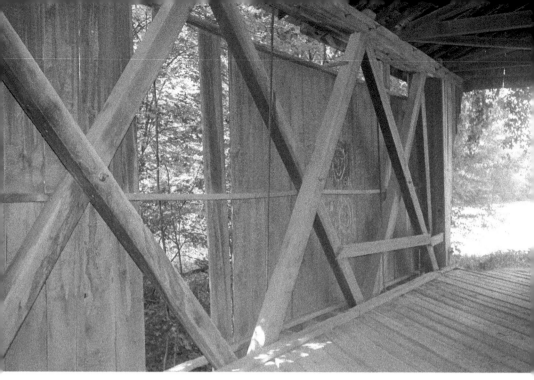

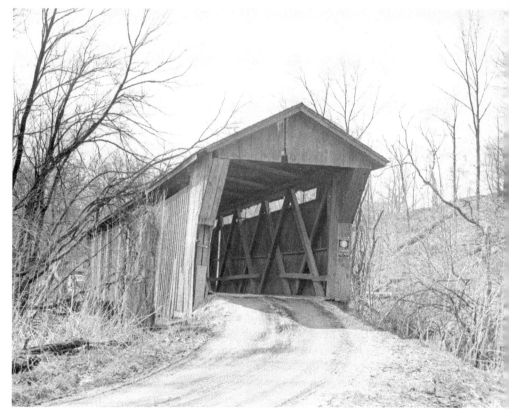

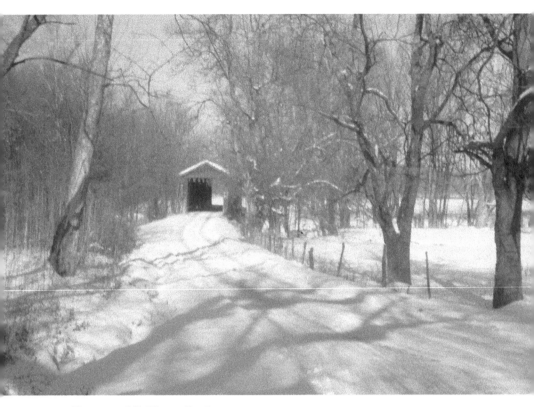

Figure 12.5. Bill Oliver collection.

Figure 12.8, a photo of the south portal, shows the internal structure of the bridge. The bridge has been restored, as evidenced by the sheet metal roof that can be seen extending beyond the rafters.

Figure 12.9, a photo from 1974, shows the restored bridge and its reflection on Bean Blossom Creek. The bridge had been standing for 103 years, but it would be lost to arson just two years after this photo was taken.

Figure 12.10 shows the approach and north portal after the 1970 restoration.

Figure 12.11 shows all that remains of the McMillan Bridge south abutment today. A few small pieces of rusty tin and nails are all that is left; all of the burned wood has rotted or been washed away by the rain and flooding. The end of one tension rod still protrudes from deep in the mud on the creek bank.

In 2012 I took my sons Jeremiah and Mason, who were seven and six years old at the time, to the site where the McMillan Bridge once stood. I was taking photos of the abutments for this book, and my sons were playing "searching for treasures," as they normally did. They climbed up on the south abutment and

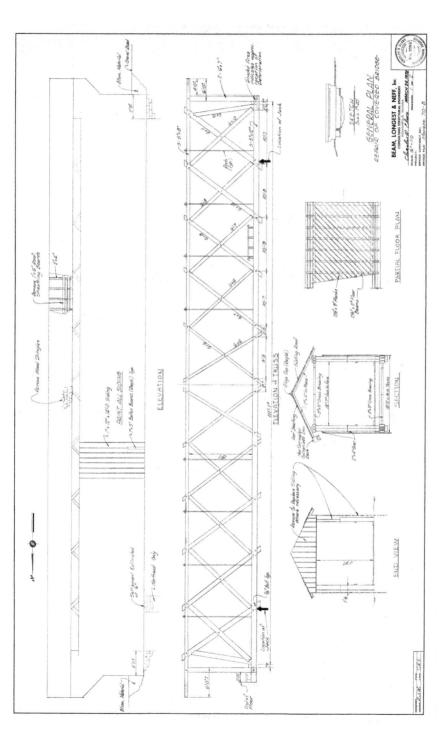

Figure 12.6. Monroe County Board of Commissioners.

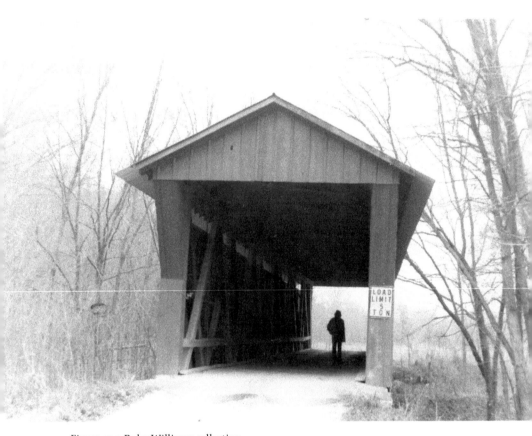

Figure 12.7. Ruby Williams collection.

found a piece of rusted metal roofing buried under the mud and leaves. I helped them pull the metal up and underneath found a small piece of burned wood and a piece of a timber with dots of red paint on it.

Very happy with our "treasure," we walked around for a few more minutes taking photos until one of my sons tripped over something protruding from the ground. Upon closer inspection, I found it to be a large iron rod from the bridge. The other end was buried deeply in the mud and appeared to have been cut with a torch, possibly by a utility company whose buried cable signs were a few feet away. I pulled and wiggled the rod from the mud until it finally came free.

The items in figure 12.12 are all from the McMillan Bridge. A rusted piece of sheet metal at the upper right is from the 1970 restoration, with some of the galvanizing still visible. At the bottom right is a rod that is 1 ½ inches in diameter with a 2 ¼-inch square nut and 6-inch square casting. These rods were underneath

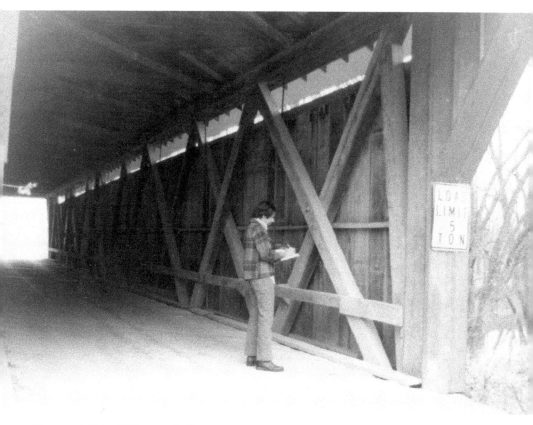

Figure 12.8. Ruby Williams collection.

the bridge and connected in the middle with the large turnbuckle at the bottom of the photo. A burned piece of wood from the fire in 1976 can be seen at the lower left. Two long bolts can be seen at the upper left side of the photo. My sons found these in Bean Blossom Creek in the fall of 2017. These could have been used to bolt the upper and lower chords or the diagonals of the bridge together. The wooden block at the lower middle is a 6 × 11-inch piece of white pine with drops of red paint on it from the 1970 restoration.

Today the ground around the site where the bridge was located is still black with ash from the burned wood. Only some rusted nails can be found today. The sheet metal roofing, bolts, tension rods, and corner castings left from the fire are all gone, most likely picked up and repurposed or sold for scrap metal.

The six-by-eleven-inch white pine timber is most likely from Michigan, as this was where the Smith Bridge Company got a lot of its timber. A unique feature

Figure 12.9. Photo by Daniel Scherschel.

of Smith's truss design is that all vertical/diagonal timbers were six inches in one dimension. At the center of the bridge, the timbers were six by six inches and progressed in increasing increments of one inch as you got closer to the ends, which had six-by-eleven-inch timbers.

Upon close inspection of the timber, one can see that there are nearly one hundred growth rings. This is substantially more growth rings per inch than today's fast-growing varieties of pine. Dr. Justin Maxwell of the Environmental Tree-Ring Laboratory at Indiana University used live tree ring chronology to estimate the date that this tree began growing. He calculated a very close estimate of the year 1682, meaning that the tree was almost two hundred years old when it was cut. With ninety-four years of visible growth rings, the upper left corner of the block would be from 1776, the same year the Declaration of Independence was written.

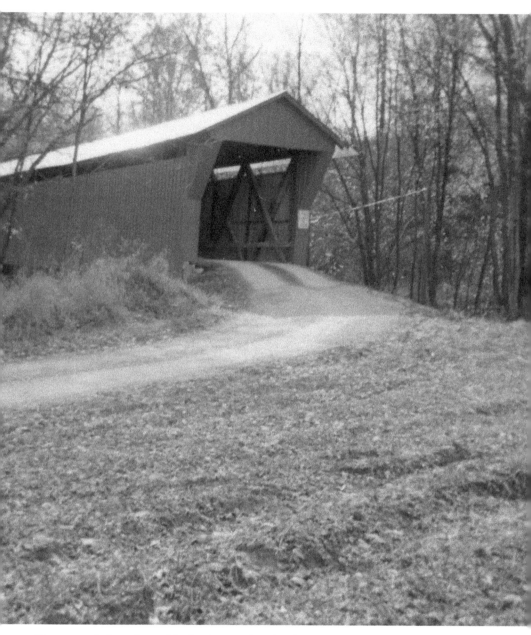

Figure 12.10. Indiana Covered Bridge Society, photo by Thomas J. Tighe, from Thomas J. Tighe collection.

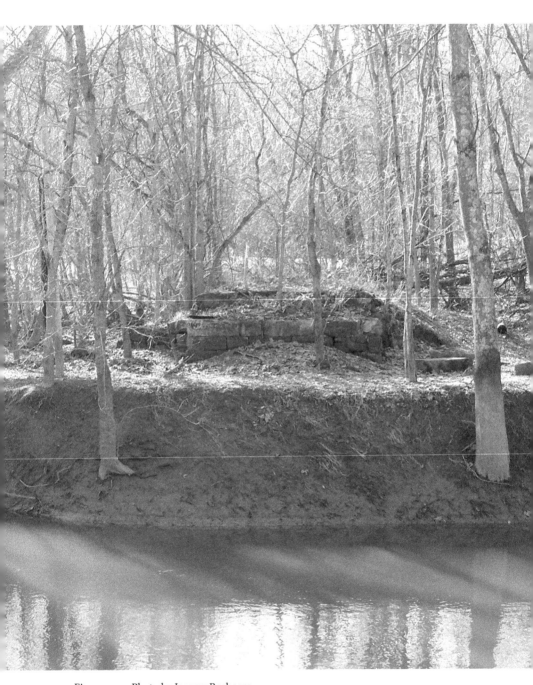

Figure 12.11. Photo by Jeremy Boshears.

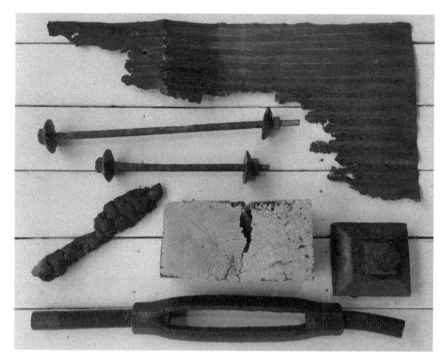

Figure 12.12. Photo by Jeremy Boshears.

In today's world of modern manufactured goods, we know the date that something was made. Even today's wooden items are not very old, due to the fast-growing varieties of many trees. Older structures such as log cabins, barns, and covered bridges are much different. Some of these things were built with lumber, timbers, or logs that came from virgin timber forests. The virgin timber harvest of Michigan in the 1800s had reports of four-, five-, six-, seven-, and even eight-foot-diameter white pine trees, though the last is undocumented.

The next time you cross a covered bridge and look at the timbers, remember that though the bridge was built in the 1800s, the timbers (trees) were growing at least a few hundred years before that—maybe several hundred!

13

MOUNT TABOR BRIDGE

Unknown–1876

The Mount Tabor Bridge was located on the south side of Mount Tabor. The bridge is listed as 14-53-11 and crossed Bean Blossom Creek in Section 9, Township 10 North, Range 2 West, Monroe County. Neither the date of construction nor the builder's name is known. This bridge was replaced in 1876, and there are no known photos of the covered bridge. Though very little information about the bridge can be found, it can be confirmed that the bridge was covered. In the Monroe County Commissioners' records beginning in 1818, the first reference to a bridge appears on the 1828 plat map, and a petition for a new road in 1833 lists a bridge. From 1840 to 1870, there are records of inspections and repairs that are less than $200 each. The December 1870 commissioners' records list "one of the abutments in the center of the creek is useless and may soon fall." A reference in 1871 is the only clue that the bridge was covered at some point in time. The 1871 records show that repairs were made and listed as "repair of sills $50.00, repairing abutments $30.00, weather boarding $40.00, flooring $60.00, roof $15.00, Total $195.00." This is the first reference to the bridge having roofing and weatherboarding. It is very possible that the bridge was a piling-type bridge that had a roof and siding added on to it. Records from 1874 to 1875 show petitions for a new bridge and list that the "current bridge" is in poor condition and unsafe.

The King Iron Bridge and Manufacturing Company of Cleveland, Ohio, replaced the covered bridge in 1876 with a 120-foot-long wrought iron bridge. The photo in figure 13.1 was taken on December 22, 1927, and shows the area where the covered bridge once stood and what's left of the town of Mount Tabor. An iron truss bridge can faintly be seen in the center of the picture, and it was in use until 1965, when it was replaced.

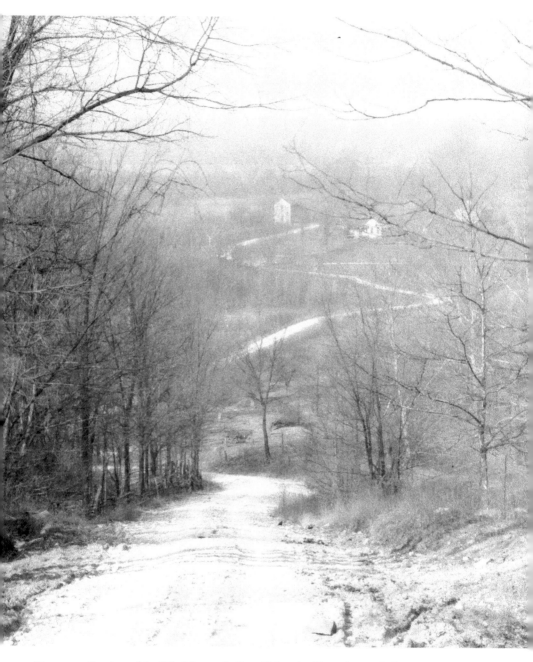

Figure 13.1. Courtesy of the Lilly Library, Indiana University, Bloomington, Indiana.

Figure 13.2. Photo by Jeremy Boshears.

Figure 13.2 looks north at the Mount Tabor Bridge over Bean Blossom Creek; the town of Mount Tabor was located on the opposite side of the creek. The current concrete bridge is about 120 feet long.

Upon close inspection of the south bridge abutment, cut stone can be seen extending beyond the concrete on the west corner. The stone blocks could be part of either the original abutment from the covered bridge or the iron bridge that replaced it in 1876. Concrete wasn't used for abutments until the 1920s. Abutment work was done for the iron bridge, but it is unclear as to what extent.

The view in figure 13.4 looks southeast across the current bridge over Bean Blossom Creek. This valuable waterway was an important shipping point that helped Mount Tabor grow and prosper into a village in the 1800s. About 1820

Figure 13.3. Photo by Jeremy Boshears.

John Burton built a sawmill and dam on the creek. A few years later, he built a gristmill upstream from the bridge and began grinding corn and wheat. The town got its true start about 1825, when James Turner and Jefferson Wampler opened blacksmith shops. William Ellett opened the first "grocery" in 1828, though legend has it that it more closely resembled a saloon in the early days. Sixty lots were laid out in April 1828 on the north side of the creek. A bridge, sawmill, and gristmill appear on the 1828 plat map, but it is unclear as to what type of bridge it was.

During the 1830s and 1840s, goods such as pork, corn, wheat, and flour were shipped by flatboats, and as many as five thousand hogs were butchered in a season. The flatboats would ship when the spring floods caused the creek and the White River to rise and the water to become deep enough. As many as fifteen

Figure 13.4. Photo by Jeremy Boshears.

flatboats were shipped in a season, some of them traveling as far as New Orleans. Noah Stine owned a large cooper shop and made barrels, and the Posey Brothers made hats from lamb's wool. There was also a gunsmith, wheelwright, spinning wheel manufacturer, and wheat fan manufacturer, which had four traveling salesmen with wagons. Mount Tabor reached a population of 350 people between 1836 and 1852, and it reached the height of its business in the early 1840s. By 1862 much of the industry had left, however, and residents moved away. By 1864 there was only one store left, operated by Levi Kean. Today all that remains in Mount Tabor are a few houses and stories from the past of a thriving, prosperous village.

14

MUDDY FORK BRIDGES

1873–1890

The Muddy Fork Bridge crossed the Muddy Fork of Bean Blossom Creek just south of Dolan on what is today known as Old State Road 37. The bridge is listed as 14-53-12 and was located in Section 10, Township 9 North, Range 1 West, Monroe County. The building contract lists a "clear span of 36 feet and an extreme length of 40 feet and roadway in clear 12 feet." J. Baldruff and George Brough built the stone abutments for the bridges at a cost of $300.00 and completed them by November 4, 1873. The Smith Bridge Company built the bridge with a Smith patent low truss at a cost of $375.00 and completed it by December 1873.

The design of this bridge was different from all the other covered bridges in Monroe County. This was a low truss style, meaning that there was no roof over the bridge. The sides were a wooden truss somewhat similar in design to other covered bridges but not as tall, and there was no overhead structure. A small roof was on the top of each truss, and weatherboarding covered the sides. The following is the order of purchase from September 1873.

Order of Purchase
Memorandum of Agreement made and entered into this 29th day of September 1873 by and between the Smith Bridge Company (an incorporated Company under the laws of Ohio) of Toledo, Lucas County Ohio of the first part and the Commissioners of Monroe County Indiana of the second part. Witnesseth that the said party of the first part agrees to furnish all material, Build and Complete the Superstructure of a Bridge across the muddy fork of Bean Blossom in Bloomington Township in the above County in accordance with the plan furnished with Bid and following Specifications say

Plan Of Bridge Smith's Patent Low Truss
Clear span of Bridge36 feetRoadway in clear 12 feet
Extreme length of Bridge 40 feet

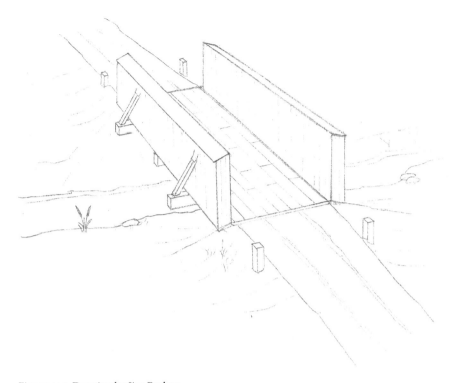

Figure 14.1. Drawing by Jim Barker.

Floor joist to be 2½ inches thick 12 inches wide and 14 feet long of good sound Oak lumber & placed two feet apart from centers. Floor plank to be 2½ inches thick and from 6 inches to 9 inches wide and to be laid diagonally and of good sound oak lumber. Trusses to be sided up with 1 inch pine boards and joints battened. Top of truss to be covered as shown on our lithographs Covering to be painted with two coats of mineral paint & oil. All timber used in said Bridge (except floor & joists) to be of first quality of white pine bridge timber. All to be done in a good and workman-like manner and to the acceptance of the Commissioners or Superintendent in Charge and to be completed within ten days after the masonary is done.

By the late 1880s, the bridge was in poor shape, and a petition for a new bridge was written. In 1890 the Canton Bridge Company won the contract for building a new bridge at a cost of $12.75 per lineal foot, and the company was to complete it by July 24, 1890.

The Muddy Fork South Bridge is not in this book, but it is listed in some other reference materials. The bridge was given the number 14-53-12, and it was supposedly built shortly after the bridge listed above, which is called the North

Figure 14.2. Photo by Jeremy Boshears.

Bridge. All of the covered, steel, piling, and concrete bridges built in Monroe County appear in commissioners' records and newspapers articles. Each of the covered bridges have several references in the commissioners' records, most beginning with petitions, followed by bidding, contracts, and repairs in later years. The confusion of a "South Bridge" most likely comes from the description of "instead of the county building a covered bridge 2 separate covered trusses were built." Both of the locations did have similar concrete bridges by the 1920s, which could lead one to believe that there were two covered bridges. The South Bridge is the location of the Greyhound bus crash of August 1949.

The drawing in figure 14.1 is a representation of what travelers would have seen when traveling across the Muddy Fork Bridge.

The Muddy Fork low truss covered bridge was located on Old State Road 37, near Dolan at the location shown in figure 14.2. This photo is looking north.

15

NANCY JANE BRIDGE

1884–1964

The Nancy Jane, or Musser, Bridge was named in honor of Nancy Jane Chambers, a Civil War widow who lived on the hill above the bridge. Legend has it that travelers wanting to cross the creek would stand on the opposite side and call out, "Nancy Jane, Nancy Jane!" She would then come down to the creek and paddle across to get them and bring them over for a small fee. This bridge is listed as 14-53-06 and crossed Salt Creek in Section 13, Township 7 North, Range 1 West, Monroe County. The single-span bridge was 160 feet long with a 9-foot overhang at each end, 16 feet wide and 14 feet 6 inches high. A shingle roof covered this structure, which sat on cut-stone abutments and had a five-ton load limit.

The *Bloomington Republican Progress* reported August 22, 1884, that "Mr. Kennedy of Rushville has secured the contract for building the two bridges which were let on Tuesday of last week. They are to be built over Salt Creek, one at the Judah mill, old Strain mill, and the other at the Nancy Jane Chambers ford. The stone work for the first mentioned bridge was awarded to James S. Williams, and Peter Fillion of Lawrence County secured the stone work at Chambers Ford." Monroe County Commissioners' records state, "Bridge erected across Salt Creek at Judah's Mill and Chambers Ford by Kennedy Bros. $5,280.00."

In 1884 the Kennedy Brothers built the Burr arch truss bridge for about $20.00 per lineal foot. It was in use for eighty years, until 1964, when it was removed as part of the Monroe Reservoir project. This bridge was located on the north side of today what is known as the Allens Creek State Recreation Area.

The Nancy Jane Bridge was submerged for a short period of time in 1964, when Lake Monroe unexpectedly began to fill during construction of the dam. An Indiana Covered Bridge Society newsletter from April 1964 reported that the Goodman and Nancy Jane Bridges were submerged but still in place. The October

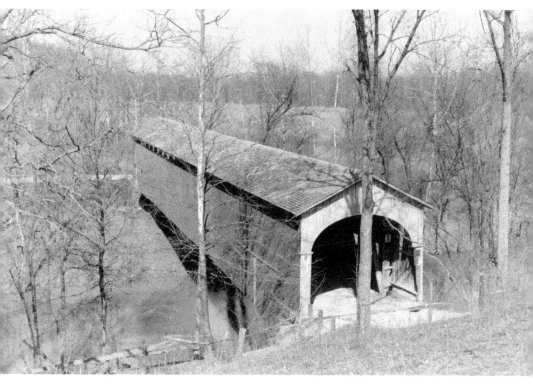

Figure 15.1. Indiana Historical Society, Covered Timber Bridge Committee collection, 1930–1979.

1964 newsletter reported that the water had been lowered and the bridges were visible again. A January 1965 newsletter reported that Harry and Marry Woolley of Richmond, Indiana, drove to Monroe County and photographed the Goodman Bridge on November 1, 1964. They reported that there was very little water in the creek and no water in the lake.

Local legends state that vandals tried to burn the Nancy Jane Bridge after the water was lowered, but the wood was too waterlogged to burn. The January 1965 Indiana Covered Bridge Society Newsletter reported that a "news item dated December 3 (1964) stated that bids would be received for removal of 19 bridges in the Monroe Reservoir." All bridges and structures had to be removed by spring, and once the gates were closed, the lake would reach summer pool level by May 1965. The Nancy Jane may have lasted until early 1965, though most records show 1964.

Some residents of the area remember watching the Nancy Jane being removed. Crews positioned bulldozers at both ends of the bridge and then pushed

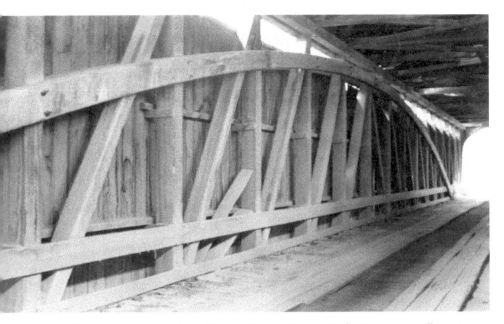

Figure 15.2. Indiana Historical Society, Covered Timber Bridge Committee collection, 1930–1979.

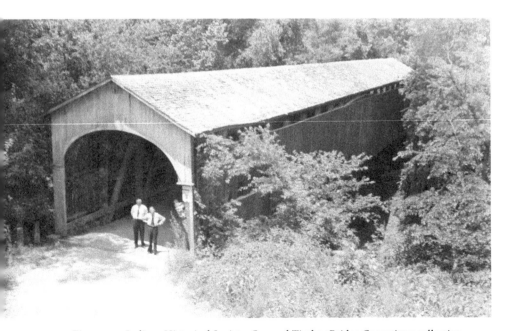

Figure 15.3. Indiana Historical Society, Covered Timber Bridge Committee collection, 1930–1979.

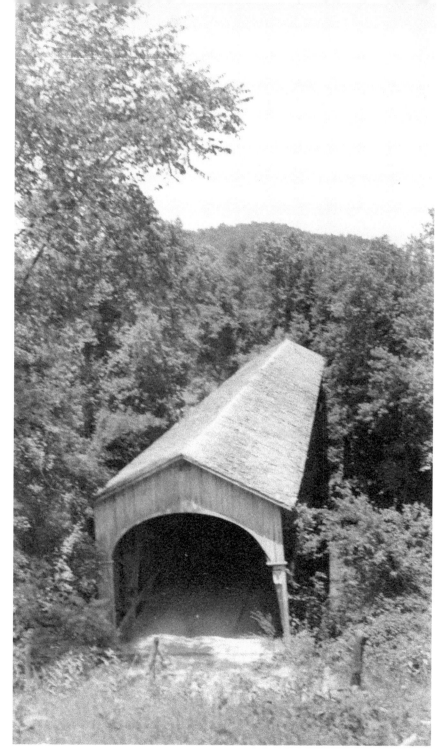

Figure 15.4. Indiana Historical Society, Covered Timber Bridge Committee collection, 1930–1979.

119

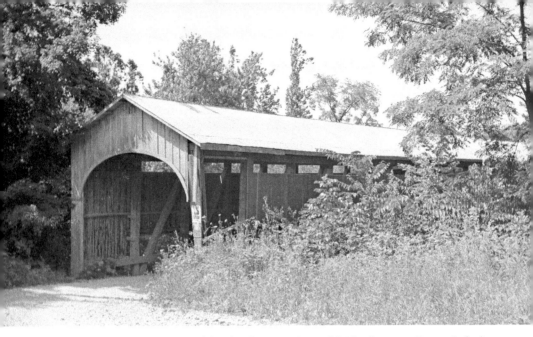

Figure 15.5. Photo courtesy of the Theodore Burr Covered Bridge Resource Center, Oxford, New York.

Figure 15.6. Courtesy of the Lilly Library, Indiana University, Bloomington, Indiana.

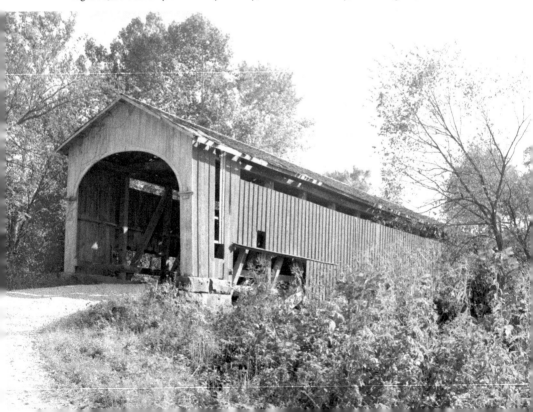

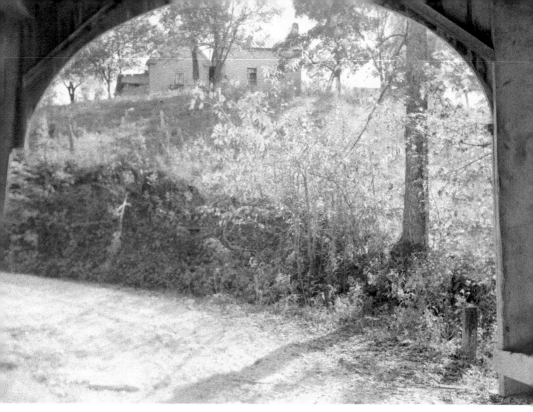

Figure 15.7. Courtesy of the Lilly Library, Indiana University, Bloomington, Indiana.

Figure 15.8. Courtesy of the Lilly Library, Indiana University, Bloomington, Indiana.

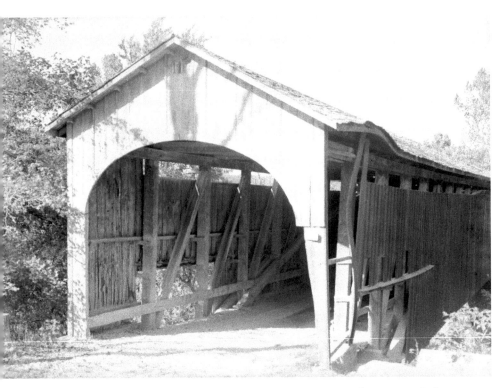

Figure 15.9. Courtesy of the Lilly Library, Indiana University, Bloomington, Indiana.

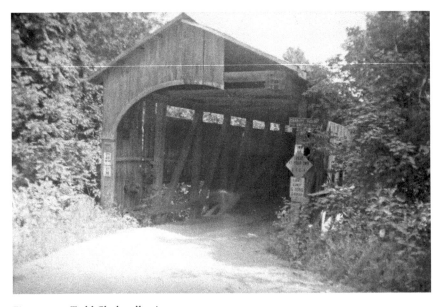

Figure 15.10. Todd Clark collection.

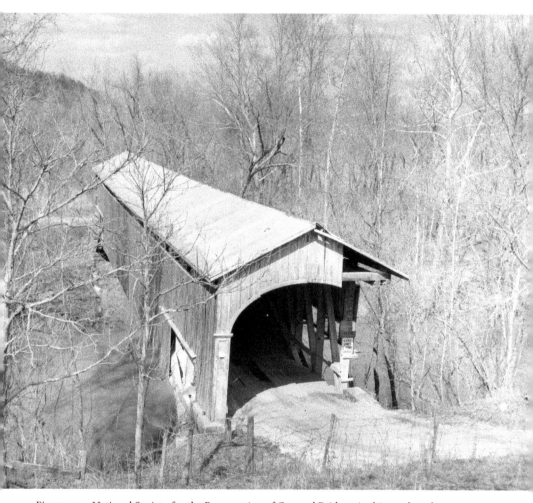

Figure 15.11. National Society for the Preservation of Covered Bridges Archives; photo by Jesse Lunger.

it off its abutments. The observers said it was not an easy task and that the Nancy Jane put up a good fight before it succumbed to the power of the bulldozers. The remains of the bridge were pushed into the creek and burned.

Figure 15.1, from March 1938, offers a wonderful view looking down the hill from where the Nancy Jane Chambers house was located.

The Burr arch truss design can be seen in figure 15.2.

The date of this photo of the south portal (fig. 15.3) is unknown, but the roof has wooden shingles, which were replaced with a metal roof in the late 1940s.

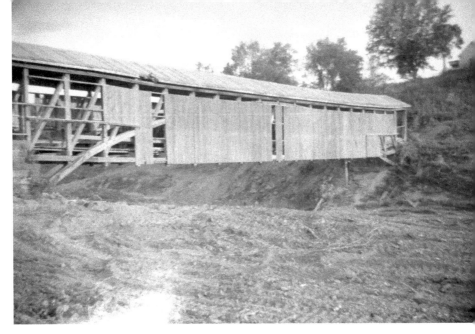

Figure 15.12. Smithville Area Association.

Figure 15.4 shows a summertime view of the south portal looking down the hill from the Nancy Jane Chambers house.

In figure 15.5, "Siscoe for Sherriff" and "Prevent Forest Fires" signs appear on the right side of the south portal on July 1, 1941.

Figure 15.6 shows a view of the north portal taken on October 12, 1945.

Figure 15.7 shows a view from inside the bridge, looking south at the house that Nancy Jane Chambers lived in, taken on October 12, 1945.

Figure 15.8, taken on October 12, 1945, shows names such as "Dave Conder" and "Walter Hibrick," along with the initials of several others, carved into the boards of the bridge.

Figure 15.9 shows a slight deformation in the roof at the south portal, taken on October 12, 1945.

In figure 15.10, the right part of the overhang on the south portal is missing, possibly from an automobile hitting it, and the condition of the bridge has deteriorated, as referenced by the "Travel at Your Own Risk" sign.

In figure 15.11, a view from 1960 shows the metal roof that replaced the wooden shingles.

In figure 15.12, time for the Nancy Jane Bridge was growing short, and clearing for Lake Monroe was underway, as evidenced by the bulldozer tracks in the foreground. The bridge was pushed off the abutments with bulldozers and burned; the house on the hill at the top right where Nancy Jane Chambers lived was also burned. For eighty years the Nancy Jane carried travelers over Salt Creek.

16

GPS LOCATIONS AND DIRECTIONS

The following information lists GPS locations and directions to where all the covered bridges described in the book were located. Directions are given starting from the Monroe County Courthouse.

Church Bridge 39.265764, −86.415087

This location is in Lake Lemon, and fisherman who use sonar to scan the lake bottom can still find the abutments.

From the Monroe County Courthouse, head north on Walnut Street for 2.8 miles.

Turn right on North Old State Road 37, and travel for 3.2 miles.

Turn right onto Robinson Road, and travel 4 miles.

Turn left onto Tunnel Road, and travel 2.2 miles.

Upon arriving at the lake, you will see a boat launching ramp; this is the old road that led to the bridge. The bridge was located about seven hundred feet to the right of the large island. When looking north from the end of the boat ramp, you will see that a point extends into the lake on the opposite shore. This is where the road went after crossing the bridge. The distance to the point is about twenty-six hundred feet, and the bridge was a little less than halfway across.

Cutright Bridge 39.071609, −86.413597

This location is in Lake Monroe near the Cutright State Recreation Area.

From the Monroe County Courthouse, head south on College Avenue, which turns left and becomes South Walnut Street, and travel for 1.1 miles.

Turn left on Hillside Drive, and travel 1.4 miles.

Continue onto East Moores Pike, and travel 0.4 miles.

At the roundabout take the second exit, stay on East Moores Pike, and travel 1.6 miles.

Turn right onto Highway 446, and travel 7 miles.

Turn left after crossing the causeway, and travel about 250 feet.

A ravine on the right side of the road was part of the old roadway that connected to the bridge. Travel about four hundred more feet, and the bridge would have been about six hundred feet due north. The water in this area is usually about twenty feet deep, and if the bridge were still there, the roof would be above the water.

Dolan Bridge 39.241608, −86.499235

This location is on North Old State Road 37.

From the Monroe County Courthouse, head north on Walnut Street and travel 2.8 miles.

Turn right onto North Old State Road 37, and travel 3.3 miles.

Upon coming to a modern concrete bridge, look to the left side of the bridge, as this is where the covered bridge was located. All of the old abutments have been removed.

Fairfax Bridge 39.005307, −86.480711

This location is in Lake Monroe south of the Fairfax State Recreation Area.

From the Monroe County Courthouse, head on College Avenue, which turns left and becomes South Walnut Street, and travel 4.2 miles.

Turn left on Fairfax Road, and travel 7.6 miles.

At the southern end of the road, turn to the left into a parking lot. From this parking area, look south across the lake. The distance across the lake at this area is about forty-eight hundred feet, and the bridge was about twenty-five hundred feet from the parking area. The average water depth in this area is about thirty to forty feet, meaning that if the bridge were still there, the peak of the roof would be roughly ten feet under the water.

Goodman Bridge 39.011477, −86.518755

This location is in Lake Monroe about a half mile northwest of the dam.

From the Monroe County Courthouse, head south on College Avenue, which turns left and becomes South Walnut Street, and travel 5.9 miles.

Turn left onto State Highway 37 South, and travel 4.6 miles.

Turn right onto the Monroe Res./Harrodsburg exit, and travel 0.3 miles.

Turn right on West Monroe Dam Road, and travel 0.2 miles.

Turn left onto Monroe Dam Road, and travel 2.8 miles.

This is the Salt Creek State Recreation Area, and there is a parking lot and boat ramp. The boat ramp is the old road that led to the Goodman Bridge. Stand at the end of the boat ramp and look west at the shoreline on the opposite side; the bridge was located about six hundred feet to the left of the boat docks. The water is about forty feet deep where the bridge was located.

Gosport Bridge 39.348736, −86.658765

This location is easily accessible from the Owen County side; the Monroe County side may require a four-wheel drive, as the last portion of the road is somewhat abandoned and only used by farmers to access their fields. Also, the road is sometimes underwater when the river is flooded or covered by debris from flooding.

Owen County Side

From the Monroe County Courthouse, head north on Walnut Street and travel 1.3 miles.

Use the left two lanes to turn left onto 45 South/46 West, and travel 11.2 miles.

Turn right onto North County Line Road/450 East, and travel 5.3 miles.

Turn left onto Fifth Street, and travel 0.2 miles.

Turn right onto East North Street, and travel 0.3 miles.

North Street eventually goes down a hill and under a concrete railroad bridge.

This is the parking lot for the Gosport boat launching ramp, and the piers from the covered bridge are visible in the river to the right.

Monroe County Side
(four-wheel drive may be needed)

From the Monroe County Courthouse, head north on Walnut Street and
travel 1.3 miles.

Use the left two lanes to turn left onto 45 South/46 West, and travel
6.4 miles.

Turn right onto Mathews Drive, and travel 1.2 miles.

North Mathews Drive turns slightly to the right and becomes North Mount
Tabor Road; travel 415 feet.

Turn left on County Road 450 West/North Mount Tabor Road, and travel
5.2 miles.

Turn left on Brighton Road, which becomes Sand College Road, and travel
1.7 miles.

Turn right onto Moon Road, and travel 0.8 miles.

The last half mile of Moon Road is where a four-wheel drive may be needed,
as the road does get somewhat muddy and washed out when the river
floods.

Harrodsburg Bridge 39.018918, −86.543586

This location is just north of Harrodsburg on Gore Road.

From the Monroe County Courthouse, head south on College Avenue,
which turns left and becomes South Walnut Street, and travel 5.9 miles.

Cross Highway 37, continue south on Old State Road 37, and travel
3.8 miles.

Turn right on Gore Road, and travel 1.1 miles.

A concrete bridge crosses Clear Creek at the location where the covered
bridge was located.

Johnson Bridge 39.229935, −86.546392

This location is north of Bloomington on Kinser Pike on the west side of Inter-
state 69.

From the Monroe County Courthouse, head north on Walnut Street and
travel 3.4 miles.

Turn left onto Bayles Road, and travel 0.6 miles.

Turn right onto Kinser Pike, and travel 1.2 miles.

After crossing over I-69, the road goes around a few curves and down a hill.
At the bottom of the hill is a concrete bridge; this was the location of
the covered bridge.

Judah Bridge 39.078817, −86.398464

This location is in Lake Monroe and cannot be seen from any road; it can only be accessed by hiking. The Sycamore Land Trust Amy Weingartner Branigin Peninsula Preserve is open to the public, and a short hike (0.3 miles) takes you down the old road that led to the covered bridge.

From the Monroe County Courthouse, head south on College Avenue, which turns left and becomes South Walnut Street, and travel for 1.1 miles.

Turn left on Hillside Drive, and travel 1.4 miles.

Continue onto East Moores Pike, and travel 0.4 miles.

At the roundabout take the second exit, stay on East Moores Pike, and travel 1.6 miles.

Turn right onto Highway 446, and travel 5.9 miles.

Turn left onto Judah Road/East Rush Ridge Road, and travel 0.3 miles.

Turn left at the Y, and stay on Judah Road/East Rush Ridge Road.

The Sycamore Land Trust Amy Weingartner Branigin Peninsula Preserve will be on the right side of the road. Parking is limited to about seven cars. Follow the trail into the woods, and after entering the trees, walk about 250 feet. At this point the trail forms a Y, and the old road that led to the covered bridge begins to drop over the hill to the left. From here it is about 1,200 feet to the water. The road ends at the water but would have turned right and followed along the creek about 400 feet and then made a hard left onto the bridge.

McMillan Bridge 39.26692, −86.59240

At the time this book was written, the Cedar Ford Bridge project was just being started.

The abutments from the McMillan Bridge can still be seen, and directions to the north and south abutments are given. The south abutment is about three hundred feet from the road, and the portion of the road leading to the abutment has been abandoned and is on private property. The north abutment is still accessible at the end of the road.

From the Monroe County Courthouse, head north on Walnut Street and travel 0.8 miles.

Turn left onto Seventeenth Street, and travel 0.7 miles.

At the roundabout take the second exit west onto Arlington Road, and travel 1.7 miles.

Turn right onto Maple Grove Road, and travel 3.7 miles.

You are now at the Maple Grove crossroads, where North Maple Grove Road crosses West Maple Grove Road. To see the north abutment, turn right; to see the south abutment, go straight.

North Abutment

Turn right onto West Maple Grove Road, and travel 1.2 miles.
Turn left onto Bottom Road, and travel 2.1 miles.
Turn left onto Old Maple Grove Road, and travel 0.9 miles.
Farmers use this road to access their fields, and it is usually in good condition. You can drive up very close to the north abutment, but most of it is crumbled and falling apart. Some of the stones can still be seen.

South Abutment

Go straight on North Maple Grove Road, and travel 1.6 miles.
The road makes a turn to the left and goes up a hill. If you look north at this location, you can see where the abandoned road went into the trees, and the abutment is about three hundred feet away.

Mount Tabor 39.310525, −86.632897

This location is at Mount Tabor.
From the Monroe County Courthouse, head north on Walnut Street and travel 1.3 miles.
Use the left two lanes to turn left onto 45 South/46 West, and travel 6.4 miles.
Turn right onto Mathews Drive, and travel 1.2 miles.
North Mathews Drive turns slightly to the right and becomes North Mount Tabor Road; travel 415 feet.
Turn left on County Road 450 West/North Mount Tabor Road, and travel 4.2 miles.
A concrete bridge is at this location on Mount Tabor Road. At the southeast corner of the bridge, the old cut-stone abutment from the iron bridge that replaced the covered bridge can still be seen behind the concrete.

Muddy Fork 39.233942, −86.50447

This location is on North Old State Road 37 just south of Dolan.

From the Monroe County Courthouse, head north on Walnut Street and travel 2.8 miles.

Turn right onto North Old State Road 37, and travel 2.7 miles.

There is a small concrete bridge where the covered bridge was located. The small bridge at the bottom of the hill 0.2 miles to the south is where the Greyhound bus crashed in 1949.

Nancy Jane 39.042954, −86.464519

This location is in Lake Monroe, but it is very close to the shore and requires some hiking to reach.

From the Monroe County Courthouse, head south on College Avenue, which turns left and becomes South Walnut Street, and travel for 1.1 miles.

Turn left on Hillside Drive, and travel 1.4 miles.

Continue onto East Moores Pike, and travel 0.4 miles.

At the roundabout take the second exit, stay on East Moores Pike, and travel 1.6 miles.

Turn right onto Highway 446, and travel 9.7 miles.

Turn right onto Allens Creek Road, and travel 2.1 miles.

The road ends here at the Allens Creek State Recreation Area, and there is a parking lot and boat ramp. Hiking or a mountain bike is required from this point.

The trail begins at the northwest corner of the parking lot and mostly follows the top of the ridge. Travel about 1.6 miles to GPS location 39.040263, −86.463737. At this location an old roadway leads north to the water, which is about six hundred feet away. This old road can be seen in some of the photos, and as you get closer to the water, the hill on the left is where the Nancy Jane Chambers house was located, for whom the bridge was named. The water is about ten to fifteen feet deep where the bridge was, and if it were still standing, the roof would be above the water.

INDEX

Note: Italicized page numbers indicate figures.

Allen, Richard Sanders, 26, 74
Allens Creek Road, 131
Allens Creek State Recreation Area,
 116, 131
Amy Weingartner Branigin Peninsula
 Preserve, 129
Anderson, Dalane, ix
Arlington Road, 129
Army Corps of Engineers, 45
arson, 8, 37, 54, 68, 96, 100

Baldruff, J., 113
Ball State University Archives and Spe-
 cial Collections, 97, 98
Barker, Jim, ix, 9, 10, 11, 114
batten, 13, 70, 114
Baxter, 15
Bayles Road, 128
Bean Blossom Creek, 3, 8, 13, 20, 30, 36,
 79, 82, 95, 96, 100, 103, 108, 110, 113
Bedford, 37, 44, 45, 70, 74, 76, 79
Bell, 79
Bennett, Edwin, 88
blacksmith, 111
Bloomington Daily Herald Telephone, 68
Bloomington Republican Progress, 53,
 88, 116
Bloomington Saturday Courier, 94
Boles Mill, 94. *See also* Judah Mill
Boshears, Gerald, ix
Bottom Road, 130
Branson, Ron, ix, 89
Bridge Church of Christ, 13, 15, 20
Brighton Road, 128
Brookville, Indiana, 10, 45, 79
Brough, George, 113
Brownings Ferry, 53
Brownstown and Bloomington Road, 88

Buchanan, Alexander, 74
Buck Lemon Furniture, 44
bulldozer, 51, 117, 123, 124
Burr, Theodore, 11, 39, 42, 48, 49, 64, 82,
 84, 120
Burr arch truss, 11, 88, 94, 116, 123
Burton, John, 111

Canton Bridge Company, 114
Canton, Ohio, 45, 79
Caswell, Bill, ix
causeway, 24, 126
Cedar Ford, 98, 129
Cemetery Island, 15
Chain Belt Company, 30
Chambers Ford, 88, 89, 92, 116
Chambers Mill, 74
Chambers, Nancy Jane, 88, 116, 123,
 124, 131
Chapel Hill, 37, 41, 43
Chicago, Indianapolis, and Louisville
 railway, 64
Childress, Phil, ix
Chitwood, Don, ix
church, 21–23, 43
Church Bridge, vii, ix, 7, 9, 13–20, *15–18*,
 76, 125
City of Bloomington, 20
Clark, Todd, ix, 15, 22, 41, 46, 73, 81, 96
Clear Creek, 3, 8, 70, 74, 78, 128
Clear Creek Pike, 74
Cleveland, Ohio, 45, 79, 108
College Avenue, 126, 127, 128, 129, 131
Collier, Bettye Lou, ix, 80, 81
Columbia Bridge Co., 45, 79
Conder, Dave, 124
contract, 9, 11, 16, 45, 88, 89, 96, 113, 114,
 115, 116

Conwill, Joseph, ix
Cook, Brad, ix
Coopers Standard Service, 67
County Line Road, 127
CountyHistory.com, 89
courthouse, 125, 126, 127, 128, 129, 130, 131
Covered Spans of Yesteryear, ix;
Covered Timber Bridge Committee, 26, 33, 34, 35, 38, 44, 46, 47, 56, 58, 59, 60, 61, 62, 63, 71, 72, 73, 90, 91, 92, 117, 118, 119
Cracraft, George, 41, 43
Cracraft, John, 41
Cracraft, Lizzie, 41, 43
Cranor, Ashley, ix
Cutright boat launching ramp, 88
Cutright Bridge, 7, 10, 24–29, *25–29*, 88, 126
Cutright family, 24;
Cutright State Recreation Area, 126

dam, 13, 20, 22, 45, 49, 51, 52, 111, 116, 127
dangerous, 52
Dayton, Ohio, 45, 79
Declaration of Independence, 104
dismantled, 20, 24, 27, 68, 88, 94
Dittemore, Bert, Jr., 54
Dixie Highway, 30, 76
doctor, 88
Dolan (town), 10, 113, 115, 131
Dolan Bridge, vii, 7, 30–36, *31–35*, 126
Douglas, Benjamin W., 14
Dumond, Susie, ix
Duncan, 124
Dunlapsville, Indiana, 11

Ellett, William, 111
Environmental Tree Ring Laboratory, 104

Fairfax (town), 37, 41
Fairfax Bridge, vii, 7, 10, 27, 37–44, *38–44*, 126
Fairfax Road, 126
Fairfax State Recreation Area, 37, 126
ferry, 3, 13, 37, 53
Fillion, Peter, 89, 116

Fillion & Smith, 37, 45, 79
flatboat, 3, 37, 111, 112
Fleener; Bridge, 13. *See also* Church Bridge
flood of 1913, 20, 64, 68
floor, 13, 64, 68, 70, 98, 108, 114
ford, 3, 8, 15, 16, 45, 88, 89, 92, 95, 98, 116, 129
Fort Wayne, 10, 30
Fox, Martha, ix, 27
Frye, John, ix

gates, 50, 117
Gatewood, Arthur Jr., 50
Goodman Bridge, vii, 7, 10, 27, 41, 45–52, *46–51*, 79, 116, 117, 127
Goodman Ford, 45
Gore Road, 70, 78, 128
Gosport (town), 8, 14, 53, 54, 62, 64, 66, 67
Gosport Bridge, vii, 7, 8, 10, 53–69, *54–67*, 127
Gosport Evening World, 68
Gosport Museum Society, xi, 54, 55
Graf, Othmar, 45, 79
graveyard, 15, 20
Gray, John, 22, 23
Grays Mill, 30. *See also* Dolan
Greyhound, 115, 131
gristmill, 37, 88, 111
grocery, 111
gunsmith, 112

Hackler, Rick, ix
Hamer-Smith building, 44
Hardman, Thomas A., 10, 45, 79
Harrodsburg (town), 37, 41, 70, 74, 128
Harrodsburg Bridge, vii, 7, 10, 52, 70–78, *71–75*, 128
Harrodsburg railroad depot, 45
Hartsock, Charles, 23
Hartsock, Maurice, 23
Harvey, A. W., 20, 23
Hege & Defrees, 30, 45, 79
Hege & Weaver, 24
Helton Gristmill, 37
Hibrick, Walter, 124
Hillside drive, 126, 129, 131

Hinkle, Ray J., 52
Hires, Charles Elmer, 44
Hires Root Beer, 44
Hobart, 45. *See also* Goodman Bridge
Howard, Billy, 24
Howard, Homer, 24
Howe truss, 10, 24, 27, 31, 37, 45, 52, 79, 82, 95, 98
Howe, William, 10

incandescent lighting, 68
Indiana Covered Bridge Society, ix, 50, 79, 105, 116, 117
Indiana Historical Society, ix, 26, 33, 34, 35, 38, 44, 46, 47, 56, 58, 59, 60, 61, 62, 63, 71, 72, 73, 90, 91, 92, 117, 118, 119
Indiana University, 2, 4, 5, 6, 14, 19, 31, 32, 33, 55, 79, 82, 92, 104, 109, 120, 121, 122, 132
Indianapolis, ix, 24, 30, 45, 53, 64, 66, 79; Bridge Company, 53, 66
interstate 69, 82, 128

J&M Feed and Implement, 82
Jacobs, Kenny, 82
James Russell and Company, 13
John Riddle Farm, 13
Johnson Bridge, vii, 7, 10, 45, 79–87, *80–81, 83–86,* 128
Johnson, Tristan, ix
Johnston, John, 13
John Young Road, 16, 20
joist, 13, 70, 114
Judah Bridge, v, vii, 7, 11, 88–94, *89–93,* 129
Judah Brothers, 94
Judah, Francis, 88
Judah gristmill, 88
Judah Mill, 92, *93,* 94, 116
Judah, Morris, 88
Judah Road, 129

Kane, Trish, ix
Kean, Levi, 112
Kennedy, 88, 116
Kennedy, Archibald McMichael, 11, 45, 79

Kennedy Brothers, 88, 92, 94, 98, 116
Kennedy, Charles, 11
Kennedy, Charles R., 11
Kennedy, Emmett, 11
Kennedy family, 11
Kennedy, Karl, 11
Kerr, Betty, ix
Kerr, Everett, ix, 16
King Iron Bridge Co., 45, 79, 108
king-post truss, 11
Kinser Pike, 82, 87, 128
Kroger, Mary Pat, ix

Lake Lemon, 13, 20, 125
Lake Monroe, 24, 27, 45, 51, 94, 116, 124, 126, 127, 129, 131
Lane, Laura, ix
Lawrence County, 89, 116
legend, 51, 53, 92, 111, 116, 117
Lentz, 20, 52
Leonard Springs, 10
Lilly Library, 2, 4, 5, 6, 19, 31, 32, 33, 55, 92, 109, 120, 121, 122
lithograph, 114
locomotive, 53
lost, 8, 37, 76, 88, 100
low truss, 8, 10, 113, 115
Lunger, Jesse, 25, 39, 51, 82, 98, 123
L. W. Jenkins Clothier, 67

macadamized, 3
Maple Grove Road, 96, 98, 129, 130
Marquardt, Ron, ix
Martin, Harrold, ix, 37, 40, 43, 45
Martin, Steve, ix, 37
Martinsville Pike, 14
Mathews Drive, 128, 130
Maxwell, Dr. Justin, ix, 104
McClung, Dale, v, ix, 14, 17, 18, 20, 22, 23, 82
McMillan Bridge, vii, 7, 10, 95–107, *96, 97, 99–107,* 129
McNeely, M. C., 95
memorandum of agreement, 113
Miami County, 9
Michigan, 103, 107
Miller, Terry, ix

Milligan, 95. *See also* McMillan Bridge

Millikan Bridge, 95. *See also* McMillan Bridge *and* sawmill

Milwaukee, Wisconsin, 30

Mitchell, George, 82

Monon Historical Society, ix

Monroe County Board of Commissioners, 101

Monroe County Historical Society, ix

Monroe Dam Road, 52, 127;

Monroe Reservoir Project, 24, 37, 45, 116

Moon Road, 53, 68, 128

Moores Pike, 126, 129, 131

Mount Ebal, 41

Mount Tabor (town), 108, 110, 112, 130

Mount Tabor Bridge, vii, 7, 108–112, 130

Mount Tabor Road, 128, 130

Muddy Fork Bridge, vii, 7, 8, 10, 113–115, *114*, 131

Musser, 116. *See also* Nancy Jane Bridge

Nancy Jane Bridge, vii, 7, 11, 88, 92, 116–124, 131, *117–124*

Nancy Jane Chambers, 124

Nancy Jane Chambers Ford, 88

National Society for the Preservation of Covered Bridges, ix, 25, 26, 39, 51, 74, 82, 98, 123

Naylor, Paul, 79

Naylor, Robert (Bob), ix, 79

New Orleans, 112

Norman, Naomi, ix

North Pike, 30

November, 37, 50, 89, 94, 95, 113, 117

oak, 13, 70, 114

Oasis cigarette, 52

Old State Road 37, 36, 113, 115, 125, 126, 128, 131

Oliver, Bill, ix, 100

overhang, 12, 13, 24, 37, 45, 52, 53, 66, 67, 70, 79, 95, 116, 124

Owen County, 8, 53, 56, 62, 127

patent, 9, 10, 11, 53, 95, 113

Peden, Joe, ix

Pedigo, Pete, ix

Pepsi, 24, 27

petition, 88, 95, 98, 108, 114, 115

pier, 54, 62, 66, 68, 69, 127

piling, 3, 8, 13, 108, 115

Polley, Brenda, 20

Pontius, Wayne, 23

Posey Brothers, 112

post office, 37, 41

railroad, 37, 45, 62, 64, 69, 127, 132

Rebman, Andy, ix

Reeves, Will C., 15

Rex mixer, 30

Richmond, Indiana, 50, 117

Riddle, Carl, 16, 22

Riddle, John, 13

Riddle Point, 13, 15

Ridge, Lisa, ix

roadway, 113, 126, 131

Roberts, Judi, ix

Robinson Road, 125

Rush Ridge Road, 129

Rushville, Indiana, 45, 79, 88, 116

saloon, 111

Sand College Road, 128

Salt Creek, 3, 8, 24, 37, 45, 49, 88, 92, 94, 116, 124, 127

sawmill, 23, 24, 95, 111

Scarborough & Wilson, 37

Scherschel, Daniel, ix, 104

Scotts Ferry, 37

September, 16, 30, 37, 70, 94, 95, 96, 113

Simpson, Jim, 52

Siscoe, 124

Smith, Robert, 9, 10

Smith Bridge Company, 9, 10, 13, 24, 37, 45, 53, 64, 70, 79, 95, 103, 113

Smith truss, 9, 13, 20, 67, 70, 98, 104, 113

Smithville Area Association, ix, 43, 48, 124

Stanger, James, 98

Stanger, Larry, ix, 98

Stanger, Mark, ix, 24, 98

Stine Bridge, 95. *See also* McMillan Bridge

Strain Mill, 88, 116. *See also* Judah Mill

Stuckey, 24
Sutherlin, 52
Sycamore Land Trust, 129

Theodore Burr Covered Bridge Resource Center, 39, 42, 48, 49, 64, 82, 84, 120
Tighe, Thomas J., 105
Toledo, Ohio, 9, 45, 53, 64, 79, 113
township, 13, 24, 30, 37, 45, 53, 70, 79, 88, 94, 95, 98, 108, 113, 116
truss, 8, 9, 10, 11, 13, 20, 24, 27, 30, 31, 37, 45, 52, 53, 64, 66, 67, 70, 79, 82, 88, 94, 95, 98, 104, 108, 113, 114, 115, 116, 123
Tunnel Road, 15, 16, 20, 22, 23, 125
Turner, James, 111

Unionville, 14, 132
unsafe, 77, 108

Wabash County, 11
wagon, 3, 94, 95, 96, 112
Wagoner, Dan, ix, 94
Walnut Street, 125, 126, 127, 128, 129, 130, 131

Wampler, Jefferson, 111
Watters, Rex, ix
Weaver, George W., 45, 79
Welch, 15
Western Bridge Company, 10, 30
Wheelock Bridge Company, 10
Whipple truss, 53, 66
white pine, 13, 70, 103, 107, 114
White River, 3, 8, 53, 62, 66, 111
Whitewater River, 11
Wiliamson, Bob, ix
Williams, James S., 89, 116
Williams, Ruby, 95, 102, 103
Williams, Wayne, 95
Williams Bridge, 95
Woolley, Harry, 50, 117
Woolley, Mary, 50, 117
wrecker, 22, 23
Wrought Iron Bridge Co., 45, 79

Young, Diane, ix, 20, 22
Young, Martha Belle, ix, 16, 20

JEREMY BOSHEARS is a machinist in the Chemistry Department at Indiana University in Bloomington, Indiana. Born in 1976, he grew up on the corner of his grandparents' farm near Unionville, which gave him an appreciation for the old-fashioned way of doing things. He graduated from Vincennes University in 1996 as a tool and die machinist, and since then his interest in family history, local history, farming, antique tractors, railroading, old tools, and antiques has taken him down many roads. In 2009 one road started him searching for information about the covered bridges of Monroe County. With the help of his wife and three sons, he has traveled in search of information and artifacts. Most days in his spare time, he can be found with his family, enjoying their hobbies together. Jeremy enjoys sharing his knowledge and historical stories with everyone he meets. From family get-togethers to meeting with friends in the antique auto/tractor clubs, Jeremy can always be found telling historical stories and looking for more Monroe County covered bridge photos to add to his collection.